C000230937

ALONG THE
DORSET
COAST

RAY HOLLANDS

The
History
Press

First published 2010

The History Press
The Mill, Brimscombe Port
Stroud, Gloucestershire, GL5 2QG
www.thehistorypress.co.uk

British Library Cataloguing in Publication Data.
A catalogue record for this book is available from the British Library.

ISBN 978 0 7524 5185 5

Typesetting and origination by The History Press
Printed in Great Britain
Manufacturing managed by Jellyfish Print Solutions Ltd

CONTENTS

Acknowledgements 4

Introduction 5

Notes on Photography 7

Along the Dorset Coast 9

ACKNOWLEDGEMENTS

I should like to thank the following people for their assistance and advice in the preparation of this book: Pamela Hogg for providing the typewritten text; Hazel Weaver for research and information; Val and Colin Pady for their hospitality and sharing of local knowledge; Julie from Portland Castle Operations Staff; staff at the following Tourist Information Centres: Bournemouth, Poole, Swanage and Bridport; Antonia Phillips and Nina Camplin from the 'Art Hut' and once again my thanks to Di for her unflagging support and enthusiasm.

INTRODUCTION

Although it is relatively short compared to that of other counties, the Dorset coastline is stunningly beautiful. Its geologically diverse landscape remains relatively unspoilt, much of it designated as part of the 'Jurassic Coast', its component parts being made up from several types of stone (Portland, Purbeck), various sands, chalks, shale and clay. The jagged, saw-toothed coastline is a picture book of geological formation and history, valued by scientists and geomorphologists the world over. More than that, this unique shoreline is a wonderful place to walk and observe; the tall but gently rolling hills beyond the cliff edge are lush and green, supporting farms and herds of clifftop cattle or sheep. Here, hillside and cliff meld into one and walking along a clifftop path it is easy to understand Hardy's love and feeling for the landscape that he evoked so powerfully in his novels.

The journey begins sedately at Christchurch and the approach to Hengistbury Head before moving west through Bournemouth and on to Poole with its busy and amazing natural harbour. A quick ferry trip (less than 10 minutes) carries one across to Studland Bay and to 'Old Harry'. Old Harry Rocks (actually chalk) at Handfast Point are the beginning of the eastern most point of the Jurassic Coast and start of the geological phenomena that are to be found along this length.

Handfast Point to Durlston Head – sounding very much like a coastal shipping forecast area – includes the traditional seaside town of Swanage with its pleasant sandy beach, recently restored Victorian Pier and just a touch of 'alternative' culture that gives it its character.

Durlston Head to St Anselm's Head is stony and precipitous and undeniably rugged. This part of the cliff line is lonely and dramatic, its massive, slabbed forms are washed and sprayed by the sea almost continually and inland there is hardly a house to be seen, just bare Purbeck hills and obdurate stone-walled fields. The weather needs to be fine!

Leaving Durlston Head and its lonely twelfth-century Norman chapel, the rocky cliff falls down to Chapmans Pool and then away to the Kimmeridge Ledges and finally to Kimmeridge Bay. The exposed Jurassic shale cliffs give the bay a grey slate appearance. At one end there is a tower folly and at the other a nodding donkey with its own oil well! After Kimmeridge the cliff leads to the picturesque Worbarrow Bay, actually part of a military firing range, so access to this delightful area is limited. Less than a mile inland lies the deserted and ruined village of Tyneham, seconded by the military since 1943 and still controlled by the MOD. Visiting the village is like visiting the film set for a B-movie filmed in the 1940s or 1950s, made more eerie because there are no actors.

Beyond Worbarrow we find some of the stars of the Jurassic Coast: Lulworth Cove, Stair Hole, Durdle Door and Bats Head. Much visited geological celebrities they may be, but even during the crowded summer months they are well worth a visit. Moving further west, Weymouth Bay presents its fine Georgian Esplanade and ever-popular, golden sands that seem to stretch to infinity. Both Weymouth and Portland Harbour have been chosen as the venue for the 2012 Olympic sailing events, giving the whole area a feeling of sanguine expectation.

After Portland the landscape becomes flatter with the unusual and almost unique (in this country) 18-mile-long shingle bar known as Chesil Beach, with its equally unique brackish lagoon, the Fleet. Chesil Beach has recently added to its list of 'famous for', being featured in a modern novel by Ian McEwan, the eponymous *On Chesil Beach*.

The next part of the journey climbs to the top of Golden Cap, the tallest coastal cliff in the south of England, before gradually descending to Lyme Regis at the western end of Lyme Bay. Lyme and its Cobb is yet another place that has acquired a certain aura of fame by literary association, namely John Fowles' *The French Lieutenant's Woman*. It is here that the journey ends close to the Dorset/Devon border looking back across Lyme Bay to the east, as perhaps did the French Lieutenant's woman at one time.

In conclusion, I hope that the images in this visual essay say something about, as well as do justice to, this compelling and interesting coastline.

Notes on Photography

As with previous books I am still using film, stubbornly old-fashioned and perhaps a touch Ludditish. However, it was brought to my notice recently that some photographers, despite being hard-line digital enthusiasts, are reverting to film once again! Perhaps like jazz, film lies dormant awaiting its revival slot – or as professional actors say, 'just resting'. I shall resist the temptation to enter debate about the pros and cons of the two methods, except to say that since acquiring a young collie as an addition to the household, keeping a darkroom sterile and dust-free has reached a new plateau.

For those fascinated in cameras and film and chemical processes the following may be of interest; cameras used were a Nikon F3, Mamiya 645 and a Bessa R4 (Voightlander) recently acquired, superb to use and wonderfully light. Towards the end of the project I also used a more recently acquired Mamiya 7, another Rangefinder that proved to be much lighter upon clifftop paths than the 645, and of course produced the large 6x7 negative.

The film range included Ilford FP4 plus and HP5 plus, Kodak TRI-X, ADOX and Neopan Across 100, all developed in Rodinal Original Developer and printed on a mixture of Ilford M. IV. RC and Fibre Warmtone or Ilford M.IV. RC Cooltone, and all processed in Harman Warmtone Developer.

The negatives all proved to come out as reasonably expected given the available light conditions at the time of taking the photographs. With a project that is continually on the move one has to play the hand that you are dealt – that is to make the best of the light and weather conditions that you have and take the photograph!

ALONG THE
DORSET COAST

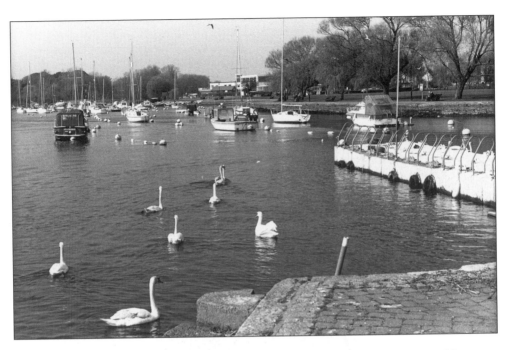

Christchurch Harbour is situated on the confluence of two rivers, the Stour and Avon. Having the advantage of the unusual occurrence of double high tides, the town has evolved as a popular haven for visiting yachtsmen, despite the difficulty of a shifting sandbar across the river mouth. Marking the entrance to the river is never an easy task until early summer when the path of the channel becomes more stable and thus predictable.

The serene nature of these photographs belie a history of conflict and movement with Saxon raids, sites of Civil War siege and castles to defend against predatory enemies. Today it is live music on the quay and food and wine festivals held throughout the summer.

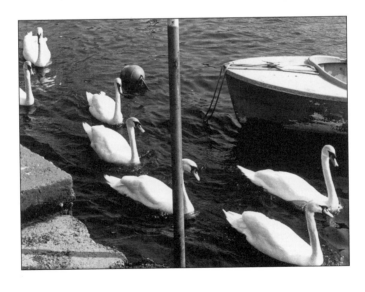

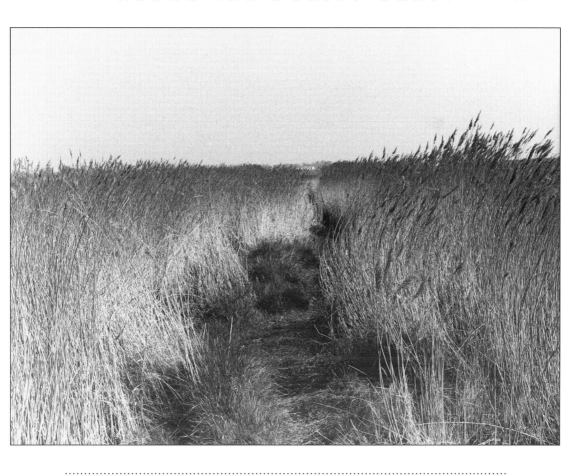

This thick swathe of reed beds lie on the marshy area behind Hengistbury Head. The area is made up of several diverse habitats that support an enormous variety of wildlife species as well as being a Site of Special Archaeological Importance. Crucial to the protection of the hinterland, without Hengistbury Head the little harbour would be left prey to the south-westerlies that surge across Poole Bay.

Both fragile and vulnerable, Hengistbury has not only been endangered by the natural environment causing widespread erosion but suffered thoughtless exploitation by mining and quarrying companies. Much effort has been put in to ensure its survival over the past few decades and as a result it has now been designated a Site of Special Scientific Interest (SSSI).

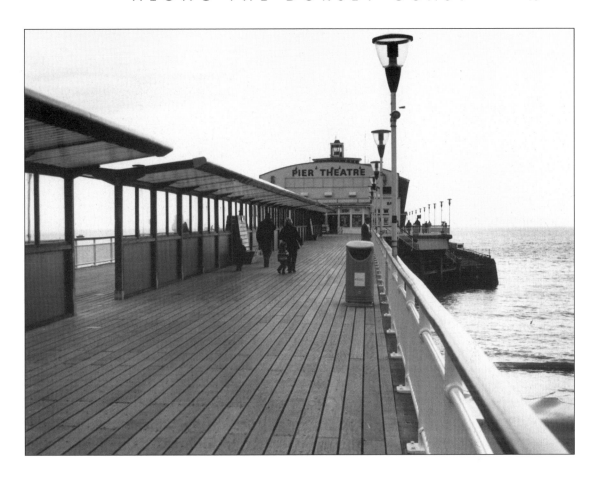

The Bournemouth Pier that we see today is basically the pier that Eugenuis Birch designed in the 1870s. Pieces have been added, bits have fallen off (or the very least fallen into disrepair), sections breached as an anti-invasion measure during the Second World War and sub-structures relaid to support further developments, all vastly different from the 100ft wooden jetty that started it all. It originally opened on 2 August 1856 before quickly being replaced by George Rennie's 1,000ft wood construction that began its life with a twenty-one-gun salute and associated pomp that befits a royal successor. Birch's pier was then opened by the Lord Mayor of London on 11 August 1886, having cost £21,600. Now the general public could enjoy the comfort of covered shelters and a bandstand presenting military band concerts three times a day in the summer and twice a day during winter months. Could such a programme be considered today? I doubt it, although there is a pier theatre.

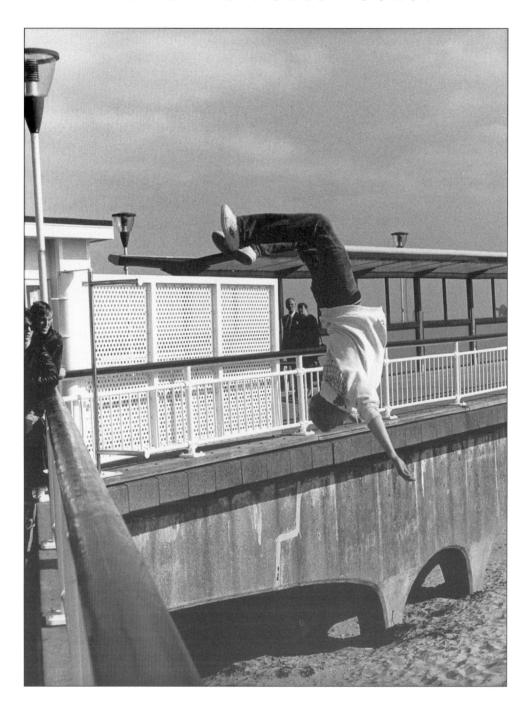

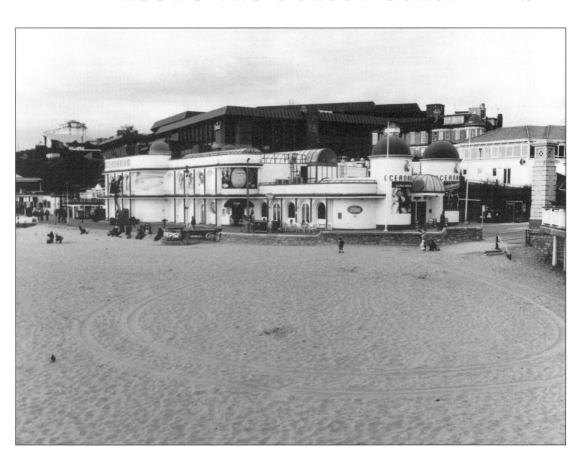

Standing on the pier my eye is attracted to a crowd of teenagers performing cartwheels and handsprings on the sands below. When the 'alpha male' of the pack began to scramble up onto the pier, I realised that perhaps something different was about to happen. With my camera discreetly tucked into the front of my shirt, I waited. Taking a short run he dived over the balustrade, performed a half twist, followed by a back somersault before achieving a near-perfect landing on the sand beneath. 'Nine out of ten!' Much applause and 'whooping' from the female members of the pack, a mixture of silent appreciation and murderous envy from the males.

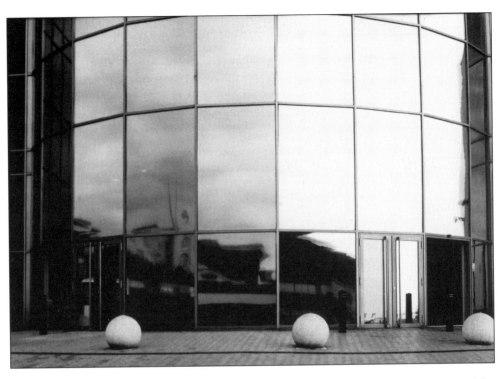

This glass-panelled building that stands on the site of the pier entrance was for a short while an IMAX cinema – unfortunately no longer. Its future is still apparently under debate and the general feeling is that it will remain so for some time. The initial development was not without controversy and whatever the final decision, there is bound to be strong opinion and fierce argument. Whatever conclusion is reached by those who decide these things, it cannot be denied that the mirror façade has impact.

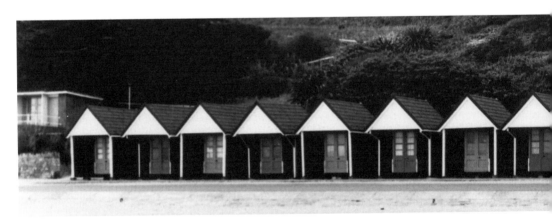

Beach huts are quintessentially English. Queen Victoria set the fashion for sea bathing and, Victorian morals being what they were with modesty to be preserved at all costs, the mobile sea hut evolved. Today they seem to be as popular as they ever were – even though we all gasp at some of the improbably high prices that individual huts have

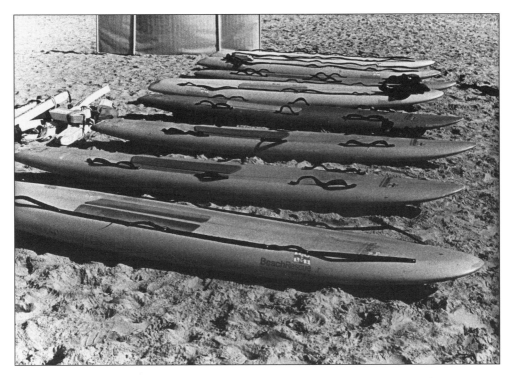

The surfboards belong to a team of lifeguards (at the time participating in vigorous training in readiness for the summer season) who will be on duty along the beach from 1 May to 30 September. Although Sandbanks is one of the safest beaches in Europe, it is good to know that highly skilled lifeguards are there if needed. What a great place to work! (Is it work?)

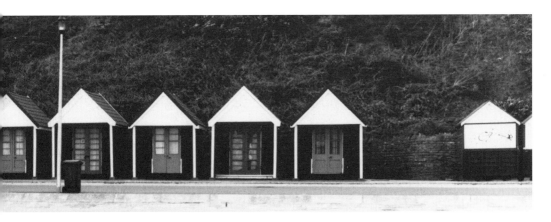

fetched in the past. This row appears to be unusually uniform, like a chain of cinema or theatre seats, yet at the same time obstinately detached and still proclaiming a strong territorial prerogative. Brits with their beach huts, Germans with their sun beds!

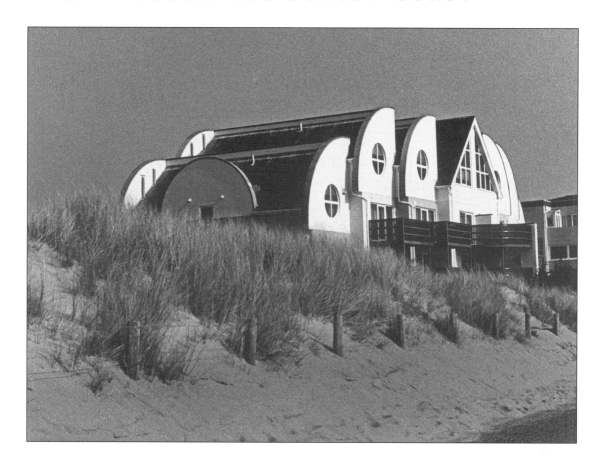

..

The beach front of Sandbanks rates as one of the most valuable pieces of real estate in the world. More expensive than Beverly Hills, properties can change hands for as much as £10 million plus; so, little wonder that its affluent lifestyle has been the subject of a TV documentary. The house in the photograph is a fine example of a 'moderne' Hollywood-style building, complete with dunes and marram grass – but probably more expensive.

Opposite: Apart from being considered the best beach in Britain, this narrow strip of sand dune is pleasantly landscaped in a style redolent of Florida or the south of France. There is a sunny and relaxed atmosphere and with your £10 million pad it wouldn't be too difficult to imagine oneself in Monte Carlo!

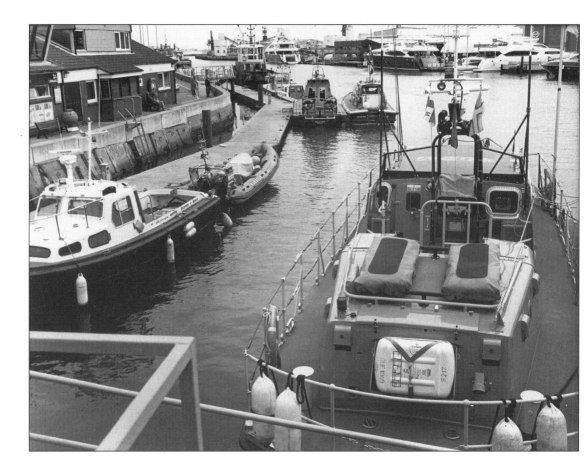

Poole has one of the world's largest natural harbours. The commissioners manage a complex and diverse organisation that sees to the day-to-day requirements of a number of users, including commercial, military, recreational and an increasing number of environmental considerations, all under the aegis of an independent trust body, the Poole Harbour Commissioners. Not an easy task when one realises that this duty covers an area that extends to over 100 miles of coastline and, as well as boating and shipping, there are three local nature reserves plus RSPB- and Dorset Wildlife-managed reserves.

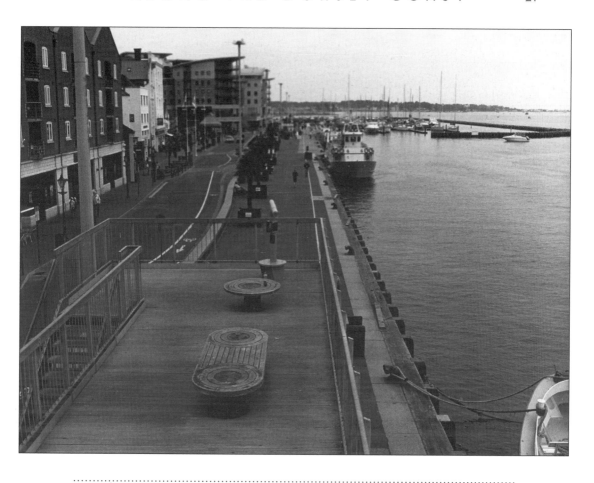

Poole quayside with its raised terrace provides a viewing platform over the harbour, or just a pleasant spot to watch the world go by.

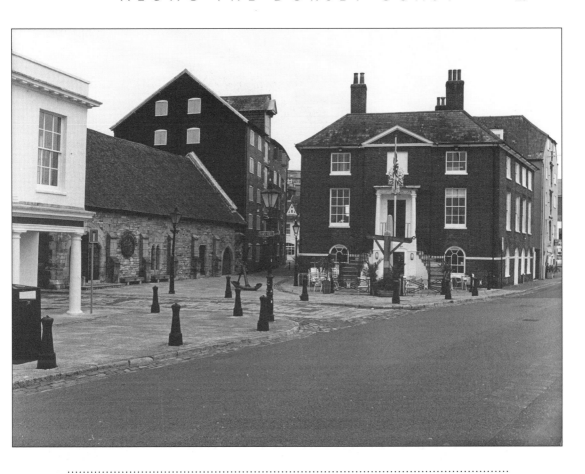

This photograph shows, from left to right, part of the old Coastguard and Fisheries House, the Medieval town cellars which is now the Local History Centre and associated historical archives (accessible to both residents and visitors), the large five-storied building known as the Old Woolhouse (now converted into the Poole Museum) and on the far right the old Customs House. All stand as architectural examples of Poole' historic past.

Opposite: Now the Poole Museum, this well-preserved building was once a Woolhouse (warehouse) for storing the wool awaiting export. In the sixteenth century, shipping from Europe would bring in wine, fruit and oil and take on board wool, tin, lead and good old English beer. This magnificent building provides an ideal setting in which to house Poole's historic artefacts.

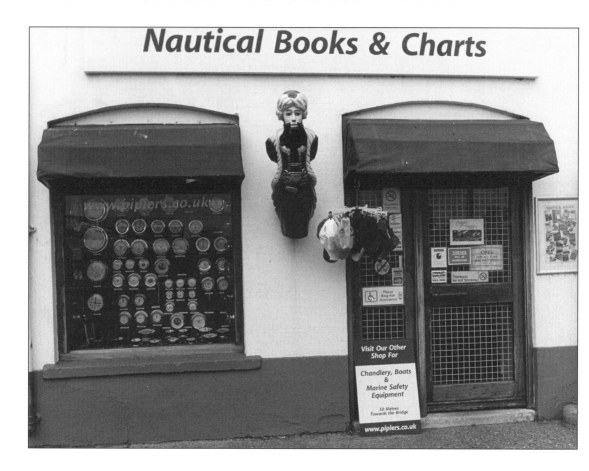

This colourful shop dealing in books, charts and seagoing memorabilia is a patent reminder of Poole's continuing association with the sea and ships.

Coastguard and Fisheries House is another fine old building to be found on the quay. Its wide, open façade is of Georgian style in keeping with much of the old town architecture. The general building style owes much to the success of prosperous sea captains and merchants who between them developed Poole and its harbour into a commercial success that remains so today.

This photograph is part of the old town (taken from the quay) and is full of architectural detail, particularly so as it was taken from an elevated position and shows parts of roofs and floor levels not usually noticed. There are at least two pubs in the picture and three café/restaurants. No need to want for sustenance in this quarter.

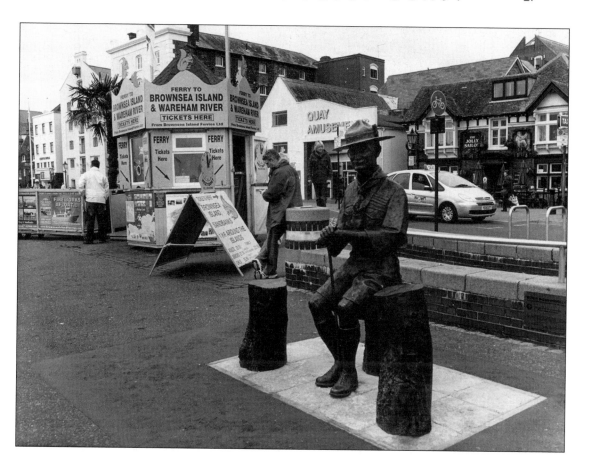

The life-size statue of Lord Baden-Powell (1857–1941) that you see on the quay today was unveiled on 13 August 2008, in celebration of his association with Poole and the Scouting Movement that was his brainchild. The striking bronze figure was created by the artist David Annand and was accepted on behalf of the Borough of Poole by the mayor, Joyce Lavender, from the local Scout groups. In what could be described as a social and academic experiment, Lord Baden-Powell organised the first scouting camp (1907) on Brownsea Island in the middle of Poole Harbour; a collection of twenty-two boys from various social backgrounds were encouraged, with his tutelage, to fend for themselves. If you have spent a wet and soggy week under canvas, in charge of a dozen or so boys (who generally love every minute of it) eating oily stews that would be better used on your walking boots, you know who to blame. More seriously, Lord Baden-Powell was an exemplary figure and perfect role model who could have stepped out of a *Boys Own Annual*. He would have been described today as multi-skilled, a decorated soldier, talented artist and writer, philosopher and social free-thinker, proficient woodsman and avid adventurer among other things. During military service he was part of the famous defence of Mafeking during its 217-day siege in the Boer War.

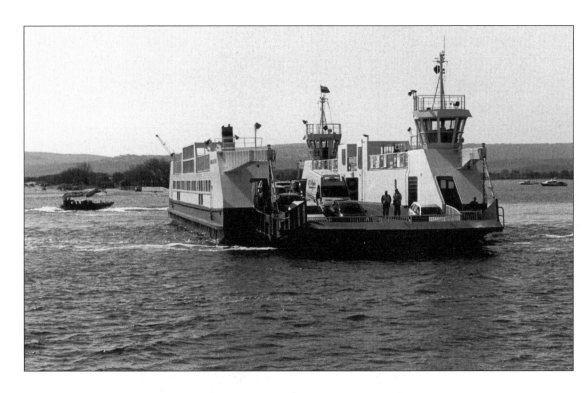

···

The 'Bramble Bush Bay' chain ferry has solved the problem of crossing the narrow entrance
to Poole Harbour, thereby saving nearly 30 miles of travel on a round trip between Poole and
Swanage. The queues in summer, however, might not do a lot for one's sanity.
The idea of a bridge had been rejected by parliament in 1929; a previous suggestion of a
suspended chain and cage arrangement had also received the thumbs down. In 1926 a coal-fired
steam-driven ferry was brought into service, managing to carry 12,000 cars and 100,000 people
in its inaugural year. This ceased after the outbreak of the Second World War, due mostly to
the military training that was to take place on the Studland peninsula. Several others operated
between the end of the war with the latest ferry being introduced in January 1994.

Opposite: The ferry works on the principle of two chains running across the harbour
mouth kept taught by heavy counterweights beneath the ground: drive wheels pull along
the tensioned chain thus propelling the ferry (floating bridge) along its length. Where the
channel is the deepest, at the Sandbanks end, there is subsequently more wear on the chain
links, which are then removed and with the aid of shackles transferred to the Shell Bay end.
This happens about once every two or three weeks with one or two links being transferred
to the other side until, of course, the shackled links reach the water; this happens about
every eighteen months or so. Each chain is about 1,250ft long and replacement costs about
£20,000. One of the chains is pictured in the photo, emerging from its pit at the water's edge.

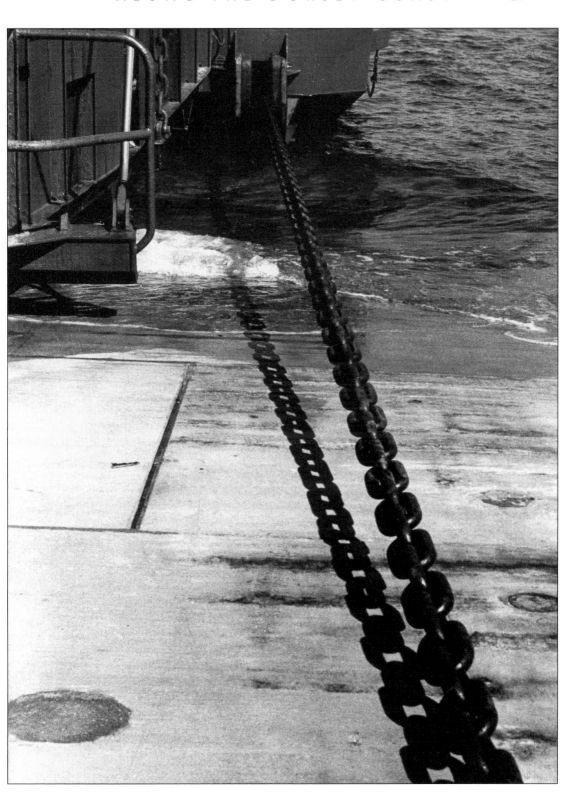

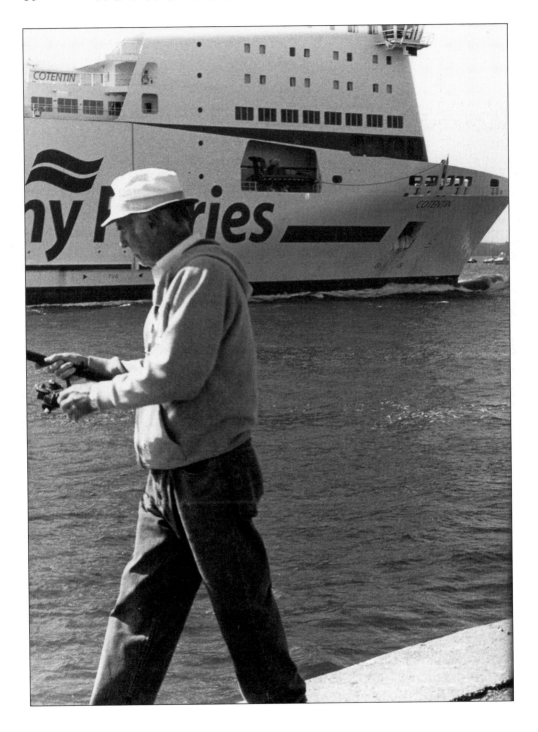

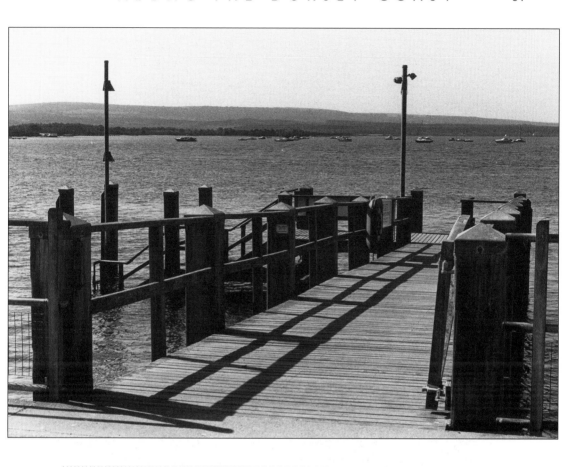

This page and opposite: The gentleman fishing beside the ferry berth is not at all put out by the Brittany Ferries ship thundering through the narrow harbour entrance – it would have perhaps proved more suitable if he had stood on the attractive wooden jetty above, no more than 60 metres away!

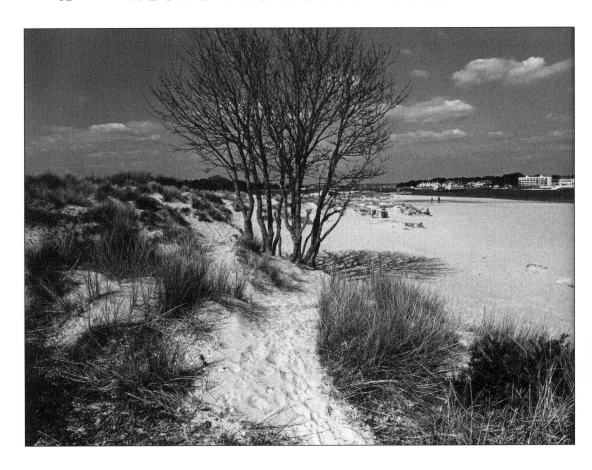

Shell Bay, named originally for the vast numbers of shells to be found in the area, is perhaps better known today for its native wildlife and nude sunbathing. The dunes and heathland are now designated a nature reserve, allegedly supporting more wild flowers per acre than anywhere else in Britain, and it claims to be home to all six British reptile species.

South Haven Point and Shell Bay are situated on the northern limit of the Studland peninsula. The area has been managed by the National Trust since 1982 and this beautiful stretch of natural coastline boasts a 4-mile length of golden sands with gently shelving waters and spectacular views.

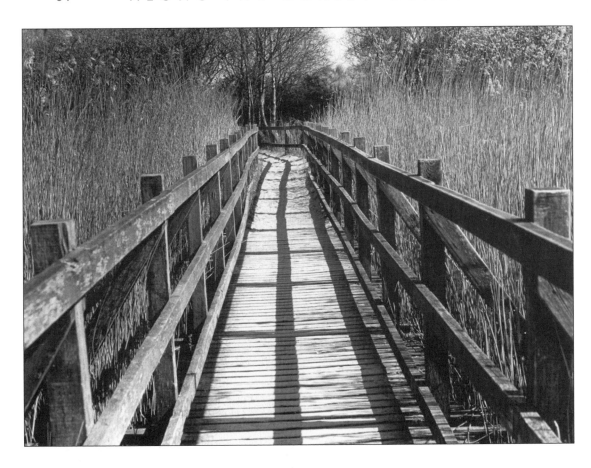

A wooden walkway through some truly magnificent reed beds. The trust has devised several trails through the dunes and surrounding woodland creating a marvellous opportunity for those inclined to a spot of birdwatching or insect discovery or just taking a walk among the wealth of wild plants and flowers.

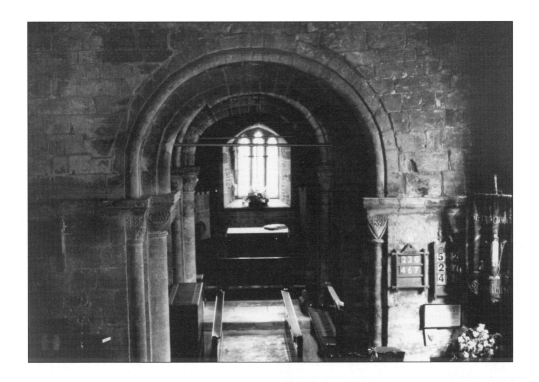

..

This page and overleaf: The church at
Studland sits in a quiet leafy corner above
the beach. It is appropriately dedicated to
the patron saint of sailors, St Nicholas, no
doubt due to the number of shipwrecks
suffered over past years along this part
of the coast. Estimated to have been built
800 years ago, its construction is of rough
stone and dominated by a low Norman
tower in its centre. The church is roofed in
Dorset stone tiles resting on a corbel table
of carved Norman grotesques. The interior
could not be described as luminous. On the
northern side the windows are mere slits
– excepting an early gothic east window,
the only light source appears to be from
the south wall, where windows were put
in during the seventeenth century. Most
stunning are the early Norman arches
shown in the top photograph, said to be
one of the first post-Conquest examples
still remaining.

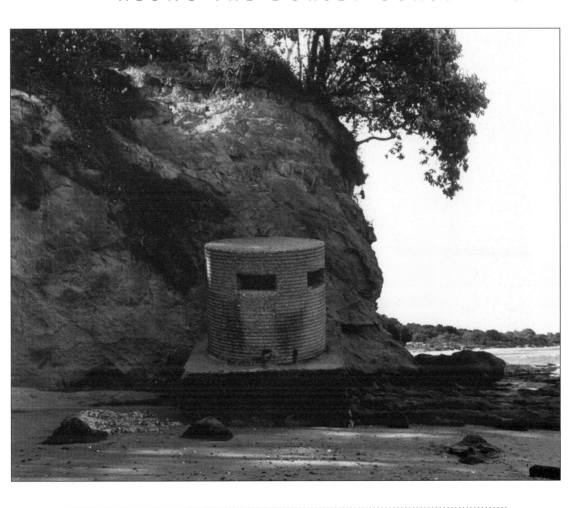

This Second World War relic looks like a haunted mask, staring out to sea from where it lies on Studland beach, with gun slits for eyes and a dark stain for nose and mouth. Has it broken away from a concrete base or toppled from the cliff above? This beach had been used as a training ground in preparation for the D-Day landings because it is similar to the beaches in France where the landing was to take place. The training practice was watched by Prime Minister Winston Churchill and General Eisenhower from a fort above the beach. Fort Henry was built by Canadian engineers in 1943 and it is now under the care of the National Trust.

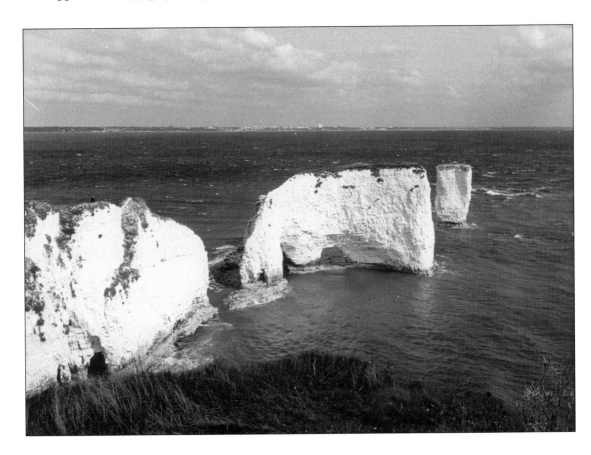

In the late eighteenth century it was still possible to walk from the headland or foreland
to the farthest eastern chalk stack, 'Old Harry'. Today that feat is no longer possible due to
persistent erosion, collapse and the formation of a large gap, 'St Luca's Leap'. At one time
Harry had a 'wife' but in 1896 she collapsed and most of her fell into the sea leaving only a
stump as a reminder of her previous existence. This group of rocks known as 'Old Harry
Rocks' signify the eastern end of the Jurassic Coast and have also been linked by some
geologists to the Needles on the Isle of Wight, the theory being that they were possibly
connected at one time and only became separated during the last Ice Age. They have been
created due to relentless erosion by the sea into the soft chalk, first forming a cave before
the chalk wall is completely pierced forming an arch across the sea. The sea finally wears
away the arch until it collapses (like Harry's Wife) leaving only the chalk stumps that are often
covered by the tide. Theories regarding the origins of the unusual name are divided between
reference to the infamous Poole pirate Harry Paye and a vernacular reference to the devil
himself, 'Old Harry'.

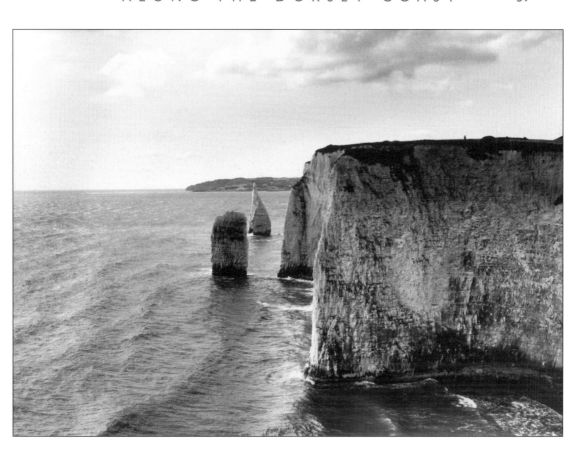

The Pinnacles lie a short distance south of Old Harry; these sticks or spires have long since lost their connecting arches but for all that are no less impressive. Standing just offshore from the vertical cliff face, their inaccessible ledges are often covered with yelping gulls and perhaps a few cormorants drying their wings in the sunshine. It's here that the cliff edge is most dangerous and walkers are well advised to show caution when following the clifftop path.

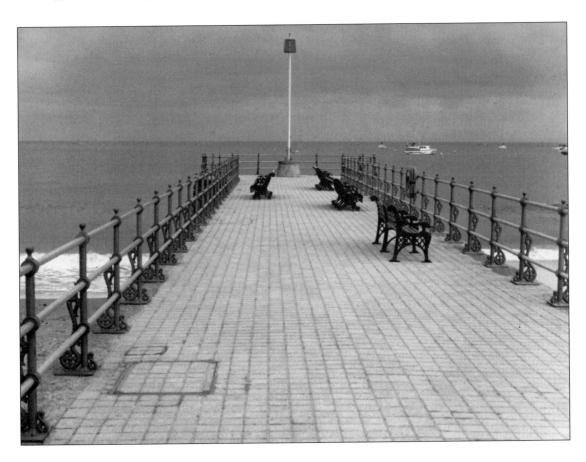

Like many other coastal situations, Swanage has been a victim of beach depletion and the subsequent need for expensive replenishment programmes. The jetty in the photograph was built in 1993 ostensibly to direct flood waters out to the centre of the bay. Whatever its efficacy it is much appreciated on a quiet summer day in the company of a good book or a large ice-cream, or both!

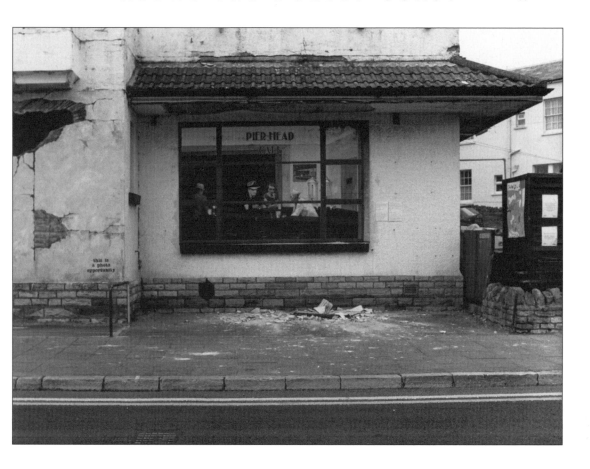

This near-derelict building, known as the Pier Head Building, started life in 1939 and has undergone a long history of uses and misuses. Owing to its sad and squalid appearance, mural artists Antonia Phillips and Nina Camplin (they run an art shop/hut adjacent to the building) decided that a pro-active approach was the only course to take if something was to be done about the eyesore next door – so they painted three murals in hope of drawing attention to their (and Swanage's) plight. The murals were to depict the building's 'past, present and possible future.' The one in the photograph is a well painted take on Edward Hopper's most famous painting 'Nighthawks', representing the past.

A view from the pier looking towards Peveril Point. Directly in the foreground are some wood pilings from the old pier, beyond which can be seen the Wellington Clock Tower. The tower doesn't actually have a clock and was originally part of a memorial monument to the Duke of Wellington. Having run out of money before its completion, the tower was sold to an affluent local Swanage dignitary, George Burt. Burt had acquired a fortune from the stone industry and had the tower brought down from London and reconstructed on the site where we see it today. Burt seemed to collect redundant stone edifices in the same manner that Saatchi collects works of art today!

Opposite and overleaf: Swanage Pier has successfully reinvented itself several times. Once just a pier for loading of the local Purbeck stone for shipping to London and other expanding cities, it then became a berth for paddle steamers that had become popular with trippers. The 'new' pier has undergone extensive refurbishment, restoring it to its original Victorian elegance, hoping no doubt to attract more visitors to the town. Today the pier is managed by a local trust, the Swanage Pier Trust (formed in 1994), not qualifying to receive any funding from a government grant. However, some Heritage Lottery funding and various schemes set up by 'Friends of Swanage Pier' have raised considerable sums towards the pier's upkeep. One such scheme, 'sponsor a plank', has been especially successful. It costs as little as £40 and entitles the sponsor to a brass plaque bearing a thirty-letter message; these plaques are then fixed to a plank on the pier decking; clearly seen in the photograph, running along either side of the pier deck.

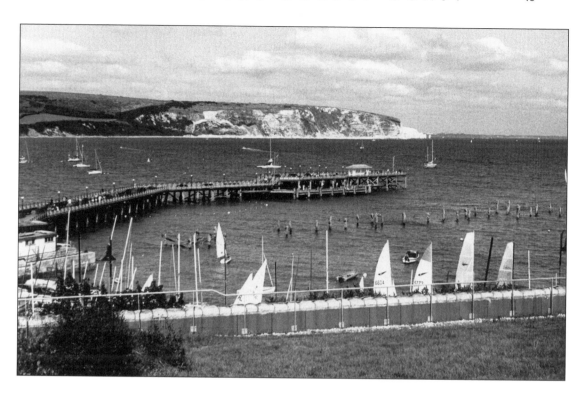

..

Despite the keen dedication exhibited by friends and volunteers there have been set-backs –
the worst being when a storm wrecked the end of the pier in the winter of 2004.
Note that one of the photographs overleaf still shows evidence of building activity. All that
remains of the original pier is a line of wooden piles sticking up out of the water just east
of today's pier. The first was built in 1859, specifically for the loading of Purbeck stone for
export around the country.
A new and longer pier was built (opened in 1896) to accommodate the public's love for
paddle-steamer trips. George Burt, the local entrepreneur mentioned earlier, started a
paddle-steamer service from Swanage, Poole and Bournemouth in 1871. By 1905 ten
steamers a day were docking at Swanage; on a summer's day hundreds of passengers would
disembark onto the new pier – often causing 'stacking'; producing much the same situation
as might occur at Gatwick or Heathrow today. Between the two world wars the pier fell
steadily into decline both with respect to its popularity and appearance; one no doubt
influenced by the other. Some of the cause was down to the gribble worm munching its
way through the underwater piling and of course the whole of life had changed somewhat
post-1914 – aspirations had taken or were forced to take diversions.

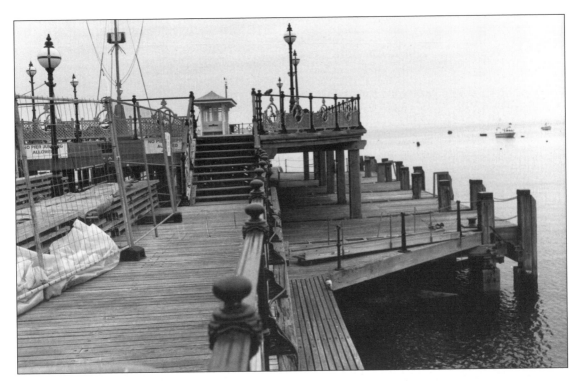

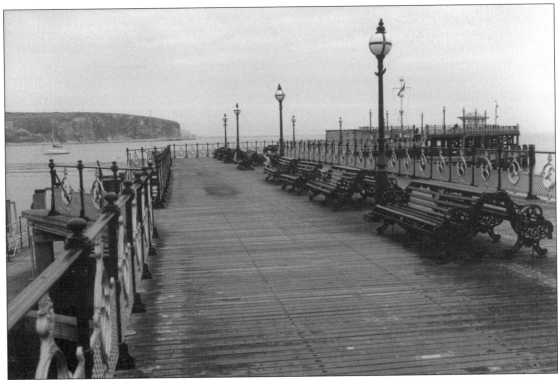

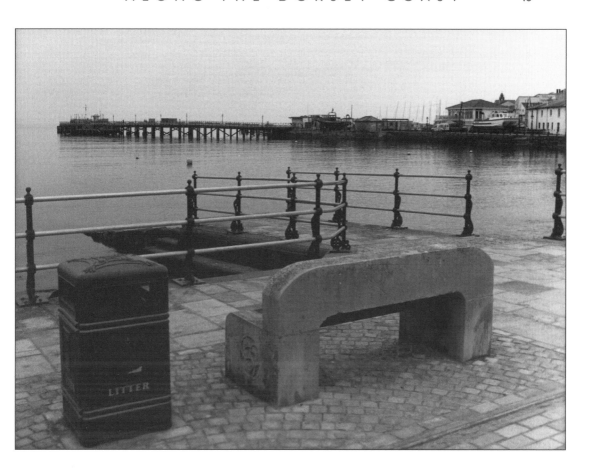

Anti-invasion measures were put in place in 1940 to many south coast piers and Swanage was no exception – the section of pier nearest the land was dismantled and later restored with a new concrete structure in 1948. The Swanage Pier Trust began raising money and in tandem with cash raised from the National Lottery were able to re-open the pier again in 1998. Great pains were taken with the refurbishment process, ensuring that strict attention to detail with respect to the original build was adhered to. New railings and Victorian lamps have all been re-cast in the original 1896 moulds. Such projects never really have a finishing line and like churches, piers perpetually demand money and maintenance.

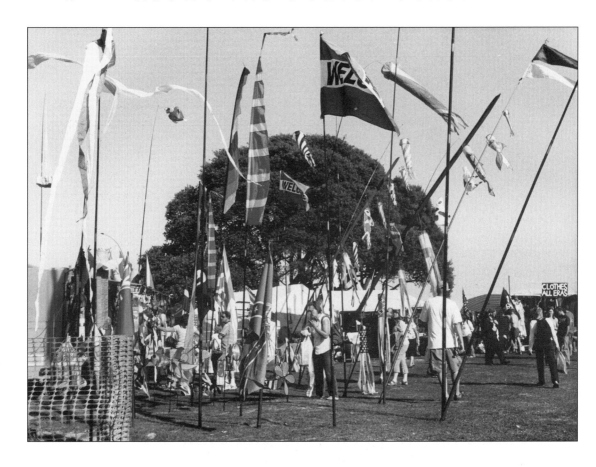

Tourists visit Swanage for its beaches and its steam railway while others flock to its famous summer festivals that include events featuring blues, jazz and folk. This photograph was taken during the summer Folk Festival.

Opposite: A morris dancer taking a well-earned break during a summer festival – 'Just rolling a fag'.

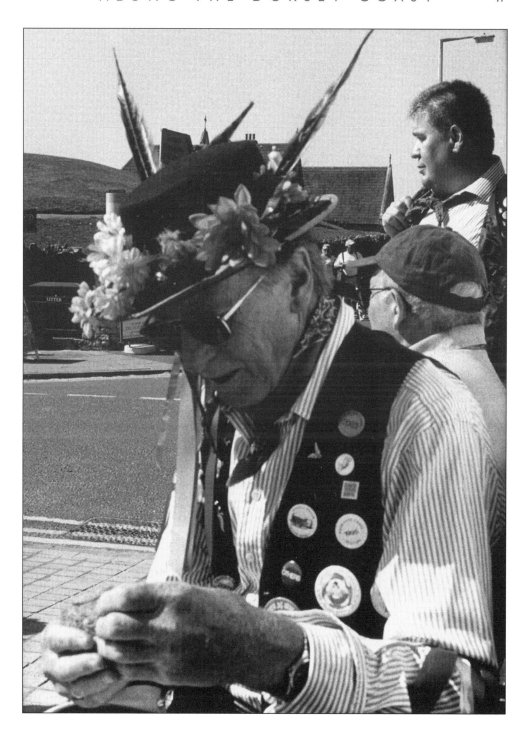

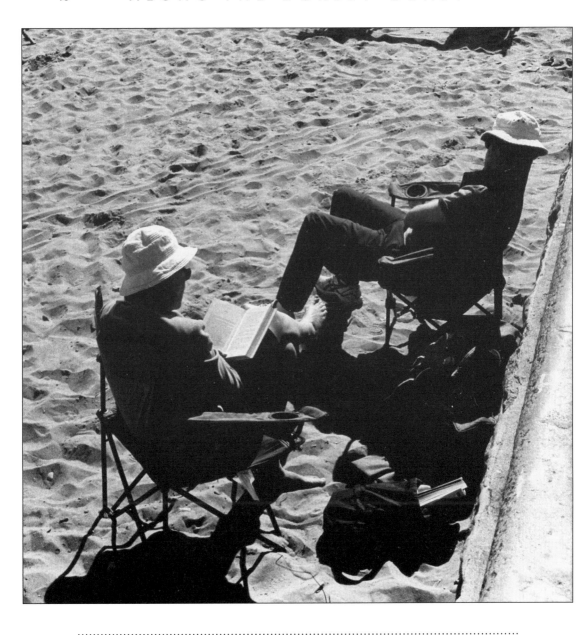

Seen more than enough festivals and dancers and yodellers, thank you very much! Time for a snooze in the chair and a quiet read of the book.

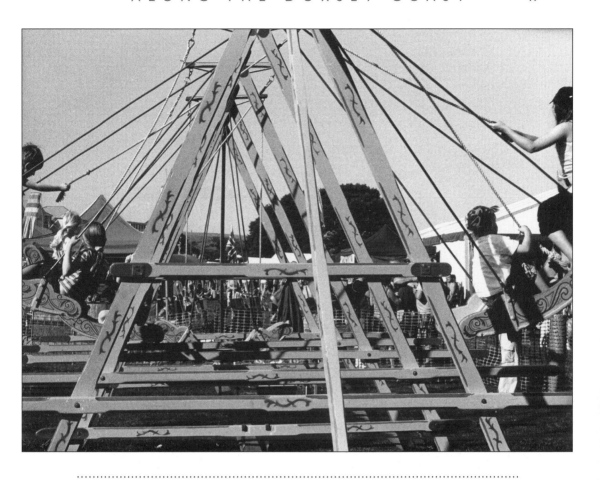

No festival is complete without a bit of a fairground. Children enjoy the swing boats while the music plays on.

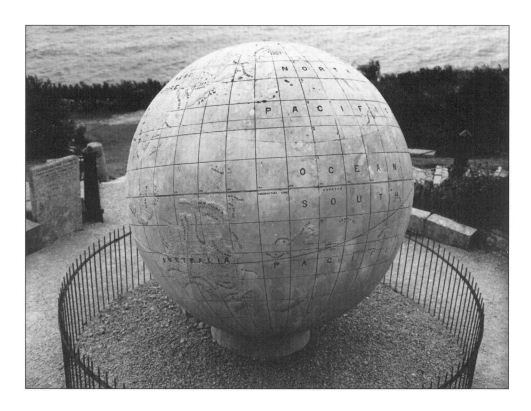

Durlston Country Park was initially the brainchild of the entrepreneur, George Burt, whose philanthropic ambition was to open up the beauty and wonders of his estate to a wider public – critics have claimed that there was a parallel agenda! However, today the 280-acre parkland site is enjoyed and appreciated by all those that take the time to explore it. It could be said to have something of interest for everybody, much of it thanks to the team of rangers responsible for its upkeep and maintenance. The area is prolific with wildlife, encouraging several interesting and unusual projects, like a video camera attached to the cliff face opposite a large guillemot colony, thus enabling live pictures to be transmitted back to the visitor centre. A quarter of a mile offshore an underwater microphone (hydraphone) has been installed to monitor and eavesdrop on marine life conversations including those of Dolphins and Harbour Porpoises – again transmitted directly to the visitor centre. If something more physical is required, there are sea cliffs to walk as well as hay meadows and woodland to investigate. The stone globe, a fine piece of Victorian bravura, was constructed in John Mowlem's stone yard at Greenwich; its fifteen segments of Portland stone being pieced together on site with granite dowels. The piece weighs in at around 40 tons and is 10ft in diameter; being Victorian it not unsurprisingly depicts the British Empire, but not with too much regard for accuracy! Whatever! It is a marvellous piece of stonework engineering and does not seem out of place alongside the estate's other follies and oddities.

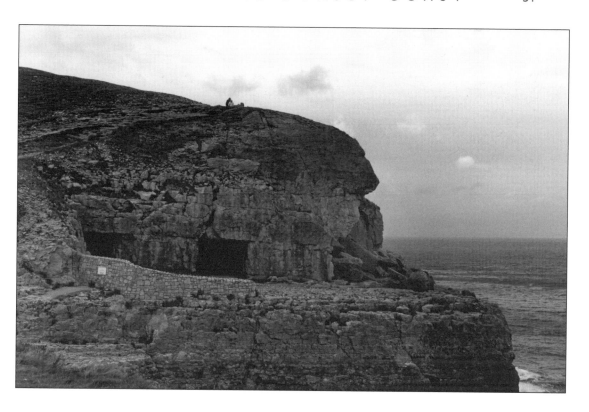

A good example of cliff quarrying as opposed to mining (inland) of the stone. Here gunpowder would have been used to open up the rock, then floor wedges driven in to allow access to the free stone. Just looking at this picture of Hawcombe Quarry it is easy to imagine the hazardous conditions that the men were faced with daily.

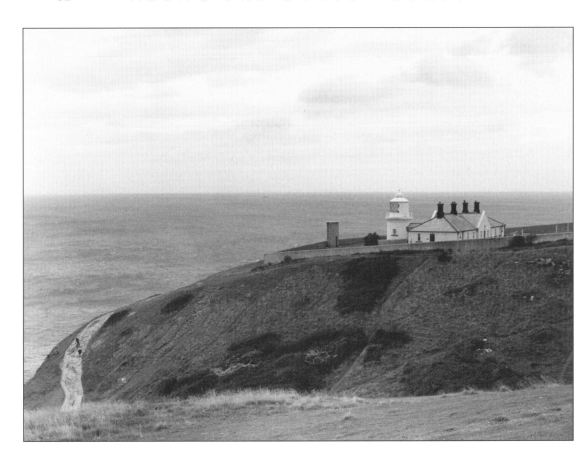

West of the quarry stands Anvil Point Lighthouse, a rather squat building erected in 1881 following three shipwrecks in quick succession in the area between 1878 and 1879. The height of the tower is only 12 metres, although the light is 45 metres above main high water. The lighthouse was electrified in the early 1960s and has been automated since 1991. It is controlled by the Corporation of Trinity House that was granted a charter by Henry VIII in 1514. Lighthouses have traditionally been painted in different colours to assist recognition by mariners during daylight hours. For example, white (like this one) is used if the surrounding background tends to be dark, or red and white stripes are painted if the background tends to be light, for example with chalk cliffs.

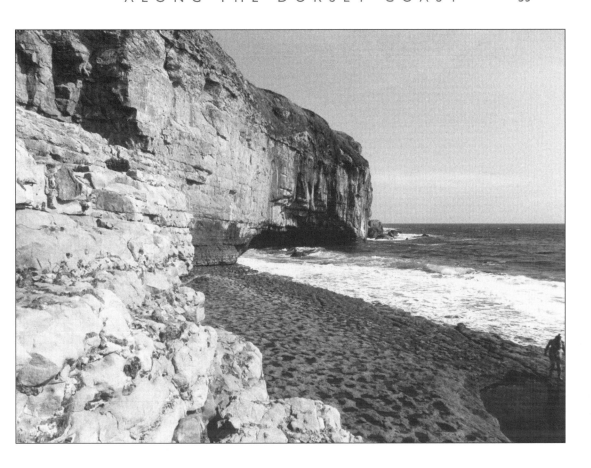

Dancing Ledge is the site of a former cliff quarry; the quarry having last been worked in the 1930s. Where the Portland stone has been excavated, there now appears to be what looks like an amphitheatre with small cave-like holes disappearing into the cliff face, which is typical of this stretch of coast between Durlston Head and St Aldhelm's Head. Almost level with the sea is a tide-filled quarryman's swimming pool. At the extreme right-hand side of this photograph you can just spot a person about to dive into the pool.

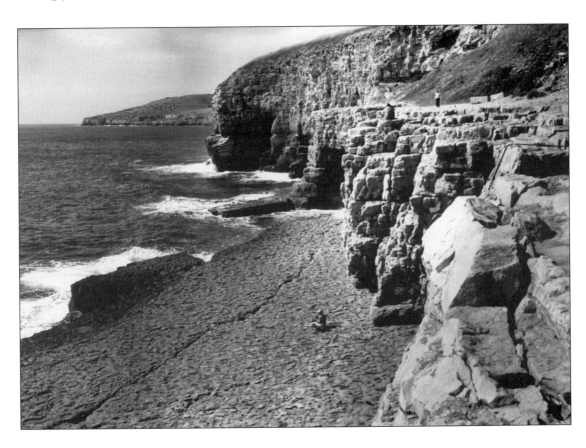

Another photograph shows a lone sun-bather enjoying the solitude of one of the rock terraces. These are not the only activities this unique combination of nature and man's intervention has to offer.

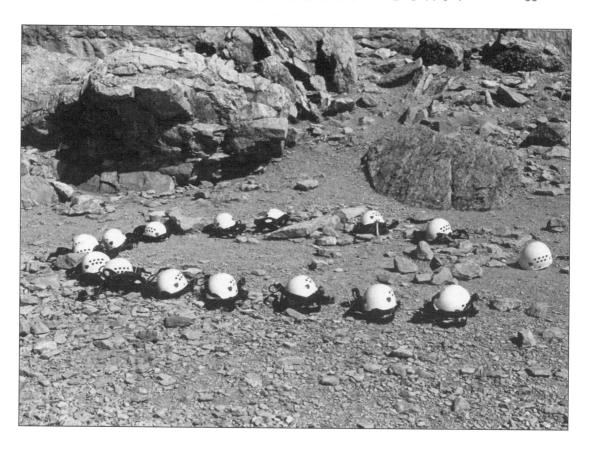

In another photograph we see a neat ring of helmets laid out in the sun, apparently awaiting a group of rock-climbers to arrive. The climb down (we won't mention the climb up!) offers plenty of interest to the nature lover. The surrounding cliff fields are managed as traditional hay meadows; that means without the use of chemicals, thus ensuring a plentiful supply of food for a variety of birds and bats.

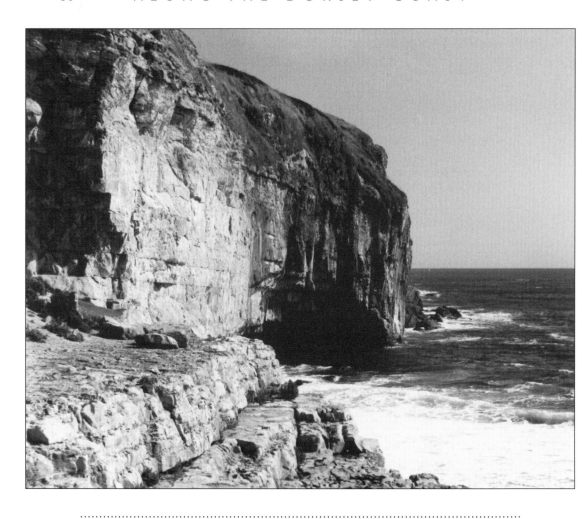

Caves formed by the quarrying provide an ideal home for several bat species, including the endangered greater horse-shoe bat. Wild flowers abound during the springtime and early summer, carpeting the area with cowslips, horseshoe vetch and sometimes the rare early spider orchid. Dancing Ledge is as enchanting as its name suggests – thought to have been christened because of the way that the waves sometimes hit the rock and seem to dance along the terraces!

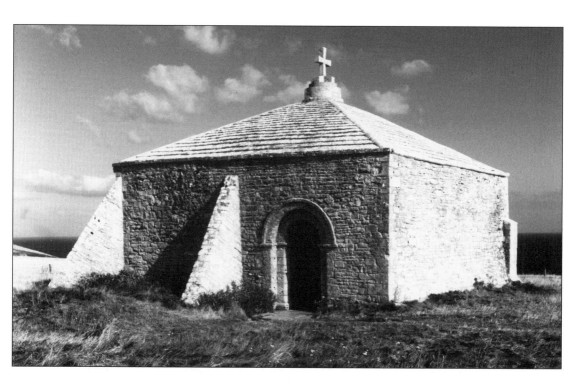

St Aldhelm's Head Chapel has always been surrounded by mystery and legend; not least about the reason for its very existence. Who would build a chapel on a remote and woefully bleak piece of headland 350ft above the sea? Where was its congregation and where was the money found to pay for the cost of building? Estimated to have been built at the beginning of the twelfth century, as can be seen the church is small and square, built predominately of Purbeck stone; the box-like shape is heavily buttressed and has a stone tiled roof surmounted by a modern cross. If there were such an architectural category as 'bog standard Norman', then the description would be very apt. There is one small window opposite the arched doorway, a couple of benches, a font and a small altar table in one corner – this was consecrated on 4 July 2005 by the Archbishop of Canterbury, the Reverend Dr Rowan Williams. Various reasons for its early provenance have been suggested. A look-out for pirates? A warning for sailors as to the treacherous waters off the Head? A lighthouse? Some comment that because it has no east-facing wall (its corners face to the four points of the compass), it was not built as a house of worship at all. Local legend has it that in 1140 a newly married couple from the village of Worth set off from the headland in a boat to travel to their new home along the coast. Hit by a freak storm the boat capsized and the couple were drowned. The story has it that the distraught father built the chapel in their memory and as a refuge for his prayers. Whatever the reality this fascinating little church will forever hold on to its mystery. Perhaps on a winter's night with rain lashing against the walls and the wind screaming into the dark cliff face there is spiritual comfort to be experienced; no matter who or why it exists. During the summer there is still a monthly service held in the chapel.

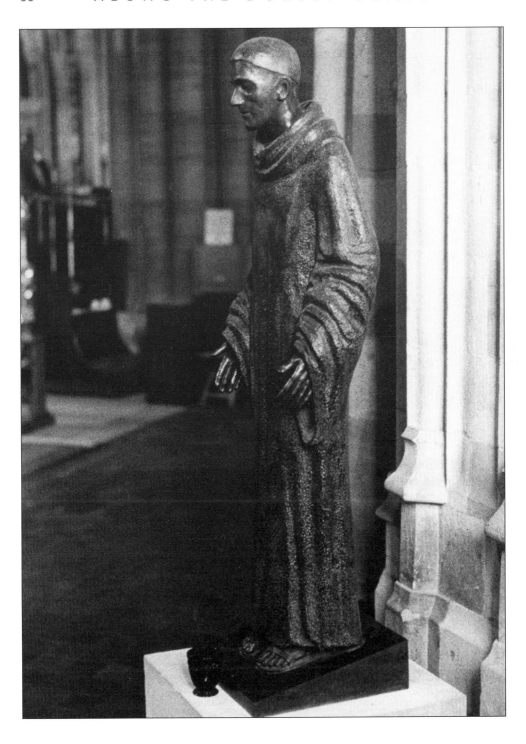

These stout-looking coastguard cottages sit beside a lonely track leading out to St Aldhelm's Head. They look as though they have been built for withstanding the frequent storms of this bleak headland. Thought to have been built in 1834 they are no longer used by the coastguard service; in fact the nearby coastguard lookout is now manned by volunteers of the National Coastwatch Institution (NCI). The cottages were originally equipped for the serving coastguards and lifeboatmen – the white shed housed a wagon which was drawn by two horses to carry equipment to wherever it might be needed.

Opposite: This pious-looking statue of St Aldhelm stands in Sherborne Abbey. St Aldhelm was the Bishop of Sherbourne and died in AD 709 having been appointed the first Bishop of Dorset by King Ine of Wessex. By all accounts he was a brilliant scholar; some of his writings even survive today. The unique St Aldhelm's Chapel is a fitting dedication to his memory.

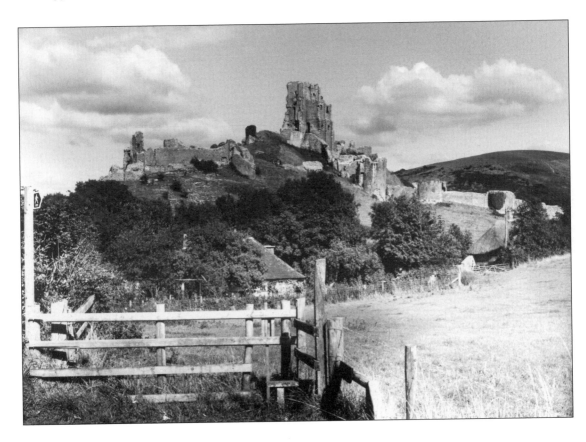

The grey ravaged look of the limestone cliffs between St Aldhelm's Head and Durlston Head is directly due to the centuries of quarrying leaving great fissures or cavernous holes where the precious building stone has been removed. The haunting spectre of Corfe Castle (3½ miles inland) is a prime example of the enduring Purbeck stone, itself looking elegantly as ravaged as the cliffs from where some of its building blocks may have been brought. Built upon the site of a previous ninth-century wooden castle, the castle we see today dates back to the eleventh century. Improvements were made by both King John and Henry III. In 1572 Queen Elizabeth I sold it to Sir Christopher Hatton, her dancing master. Unfortunately in the mid-seventeenth century the Parliamentarians, after a long siege, sacked and destroyed most of its fabric. Today it still sits high upon the hill overlooking the village of Corfe, a sombre yet majestic patron, sagely ruminating its past with great dignity.

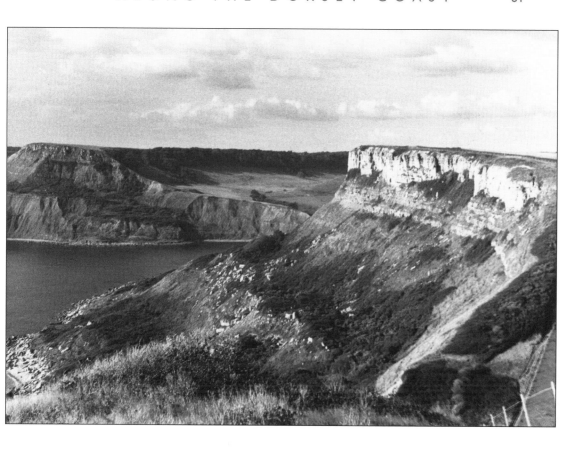

The mouth of Chapmans Pool, a pretty cove lying in a valley between St Aldhelm's Head in the south-east and Houns-Tout to the west. There was once a carriage drive around the perimeter allowing access to the pool as well as Renscombe and St Aldhelm's Head. However, soon after the turn of the twentieth century the road began to collapse owing to subsidence along the undercliff and is now completely destroyed.

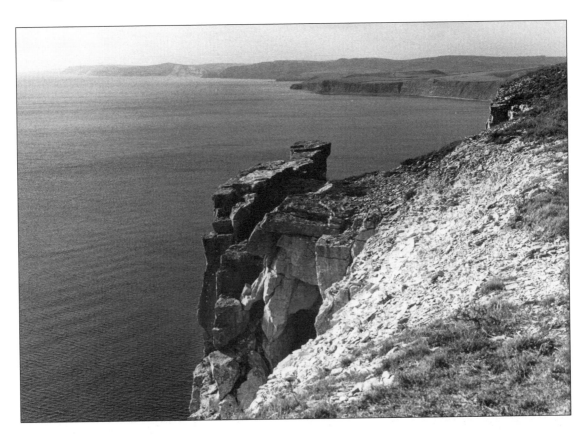

...

St Aldhelm's Head, also known as St Alban's Head, comprises a large outcrop of Portland stone that mixes with a vein of Purbeck. It is here that we see skeletal cliff faces, pared to the bone by winter storms and unmerciful winds.

Opposite: The pristine folly in the photograph was taken after the completed refurbishment in 2008. It was built sometime in the early 1830s by the Reverend John Richards, who had changed his name to Clavell subsequent to inheriting the Smedmore estate in 1817. Several reasons or theories as to why someone would build such a tower, ranging from observatory to watch tower have been suggested, but considered opinion gives most credence to it just being a folly. It is apparently the inspiration for P.D. James's *The Black Tower* and a known landmark for Thomas Hardy's courtship of Eliza Nicholls. But such fame was no safeguard against misfortune – a fire in the 1930s nearly burned it to the ground and with its instability and rapid deterioration it was predicted that it would end up in the sea. Having acquired £900,000 to pay the cost to dismantle the tower and move it back 80ft, the leaseholder, the Landmark, hope to recoup some of its expenditure by renting out this Grade II listed building as an exclusive holiday let. With the views and beautiful rolling countryside it should be a worthwhile experience.

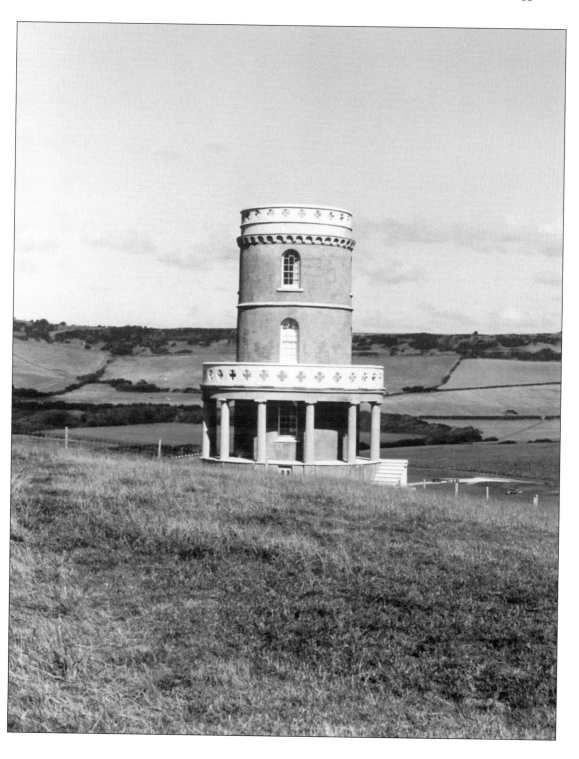

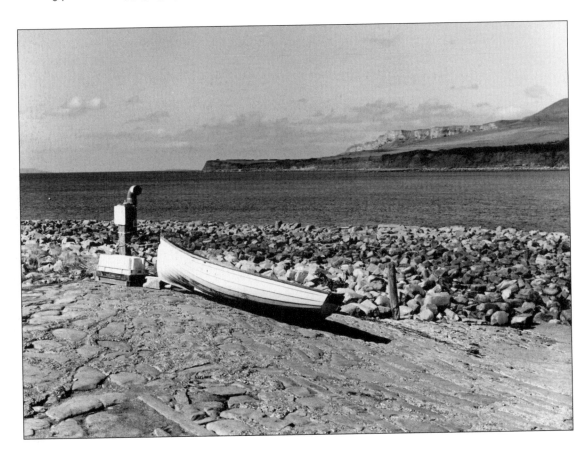

..

This picture looks directly across Kimmeridge Bay from beneath the Clavell Tower. The sand
along the shore of this sheltered bay is dull and greyish but apparently the snorkelling and
diving here are superb. Known for its eponymous Jurassic shale cliffs, it is also home to the
Purbeck Marine Wildlife Reserve. Set up in 1978, it is the oldest voluntary marine life reserve
in the UK. A marine centre adjacent to the boat slipway offers a wealth of information
regarding local marine life and activity. It also boasts an on-site live seabed camera that can be
viewed and controlled by the visitor. Best of all, it's all free!

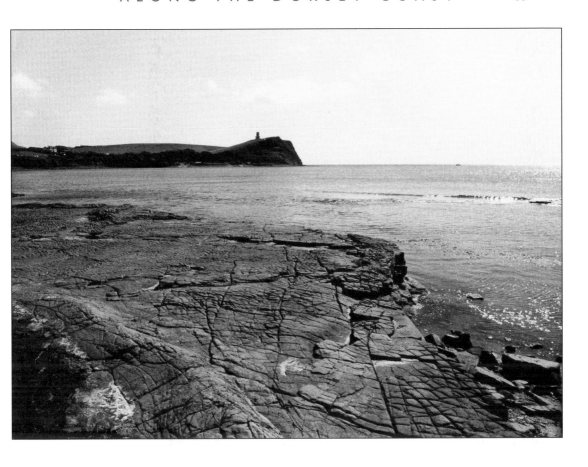

Looking across to Clavell's Tower from one of the skirts or striated plateaux of rock which stretch out into the sea and that are a feature of the area.

Here the bay provides an interesting mixture of small rocks, large slabs and shale cliff. It is in these Kimmeridge shales that hidden fossils can be found, the same leaves of shale that the Romans fashioned into jet-like jewellery centuries ago in a time when it was sought after for its hardness and ability to acquire a high polish.

Opposite: Found at the water's edge of the bay. Not quite sure what it's for but it's obviously no accident. It's a marvellous balancing act if not drilled or glued and fitted over a metal rod. Part of some ritualistic Shaman ceremony? Whatever, it's a great work of art!

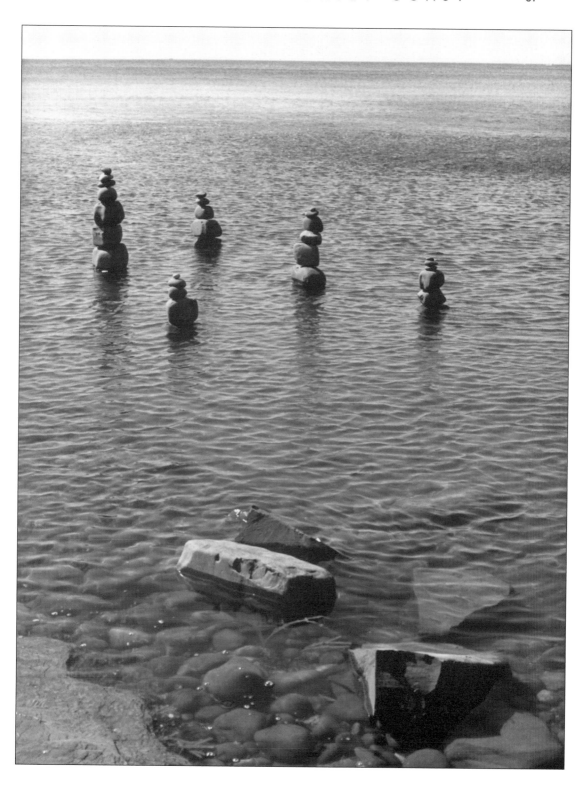

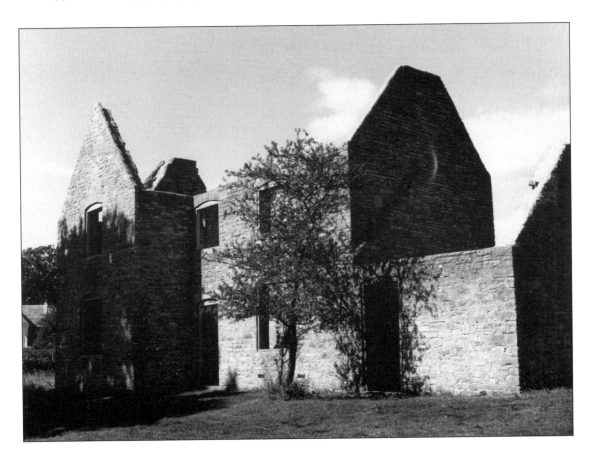

Tyneham village, or more accurately perhaps Tyneham 'ghost' village, lies a mile inland from the coast at Worbarrow Bay. In late 1943 the entire village and surrounding area were given a compulsory evacuation order by the military: nobody has lived in it since. It is estimated that around 100 properties were involved, accounting for around 250 people, all of whom were promised that they should be able to return to their properties once the war had finished. That promise has never been kept! In fact a compulsory purchase order was put in place by the MOD in 1948 – after much protesting and lobbying a public enquiry took place and a government white paper decreed that the area was needed specifically for military training purposes. Any campaign for rehabilitation by the villagers was virtually ended. Naturally, without attention the village structure began to fall into ruin. However, clearance and making 'safe' dangerous buildings has ensured that the area may now be open to visitors when firing or military activity is not in progress. The range walks and the village itself are open most weekends – but it is always worth checking in advance.

The old school house is still in good repair, as is the local church. The school (now a museum) was opened by Nathanial Bond in 1860 and was shut in 1932 owing to a lack of pupils in the area.

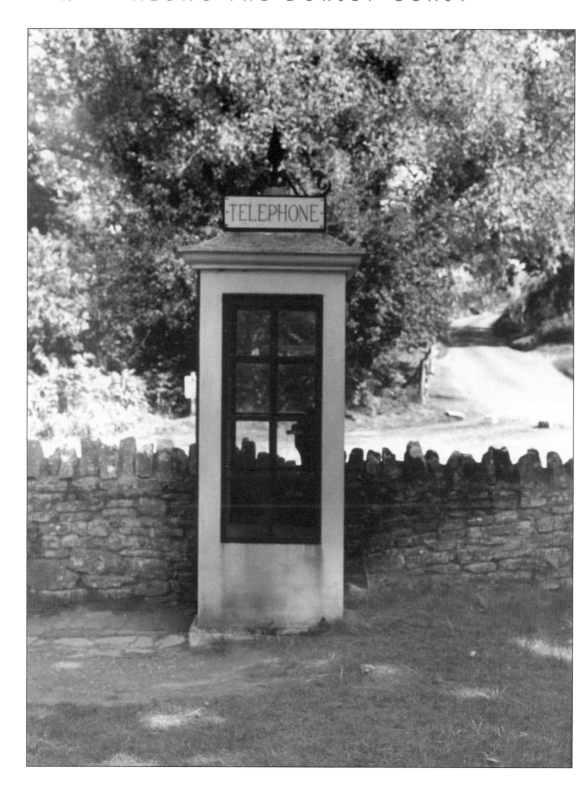

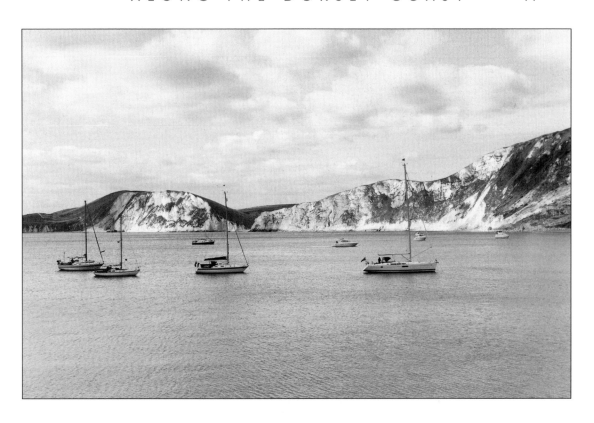

Worbarrow Bay, looking serene with its masted yachts bobbing gently on its quiet waters, belies the obvious power of the sea that has helped to form this deep indentation into the coast's geology. At one time there were fishermen's cottages around the bay and a coastguard station with its own cottages that stood behind the slipway that you can still see parts of today.

Opposite: Descriptions of Tyneham before the war indicate a small tight-knit rural community, set in quiet isolation between the Purbeck hills – a land where a community was thrown together by its geographical remoteness; schoolchildren could take days off to help at harvest time as part of a natural pattern. This photograph of the village telephone box somehow evokes a summer timelessness that must have existed then. This little note left pinned to the church door when the last resident to leave, Helen Taylor, says everything about the people, the place and the time:

Please treat the church and houses with care. We have
given up our homes where many of us lived for
generations to help win the war. To keep men free.
We shall return one day and thank you for treating
the village kindly.

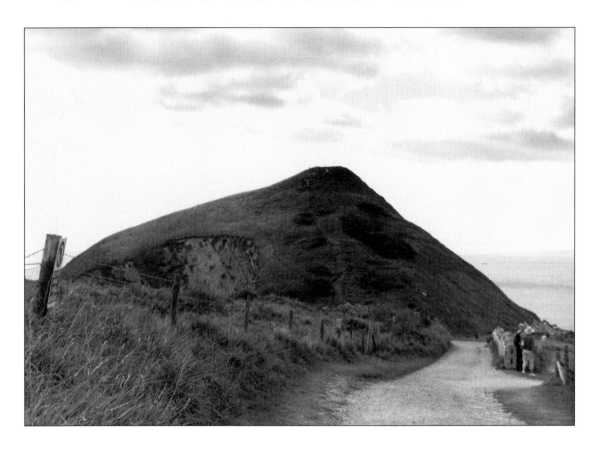

The conical hill that you see above is known as the Tout and would have been the site of the coastguard lookout position. From the hill there are uninterrupted views both to east and west.

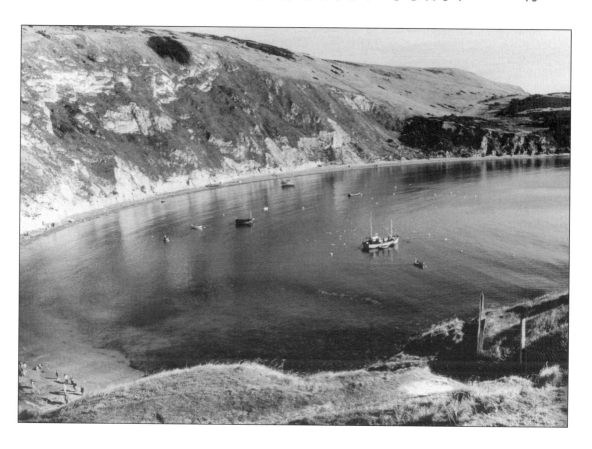

Lulworth Cove must be one of the most appealing and unusual features around the whole coastline of the UK. Its almost perfectly circular structure is due directly to the unique geology of its situation and the relentless powers of river and sea. Needless to say, it is a magnet to tourists and attracts over a million visitors a year; a heritage centre at the cove exhibits a comprehensive history, both social and geological, and is open the whole year round. The exhibition explains how the cove has formed, displaying geological images of the various bands of rock, clay and sand that have various resistance to erosive elements such as the wind and sea. The photograph shows the arced formation, caused by the waves having to run through the narrow entrance, an effect known as wave retraction.

The photograph of coiled rope reminds us that while tourism underpins the local economy it has not been the sole industry for the area. In this shot beside the jetty, the bay can be seen curving dramatically away, already forming a part of a near complete circle.

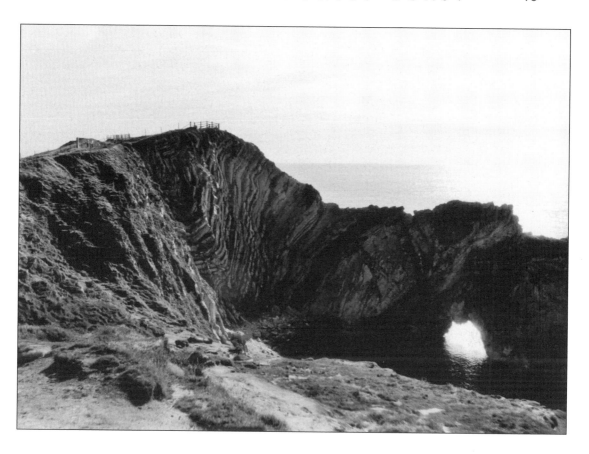

This page and overleaf: Stair Hole represents a cave in the making, the sea having already battered and worn a hole through the limestone, forming a small arch, and is busy eroding away at the soft clay behind. As in the other photograph, it is a fine example of geological folding, stimulated by the tectonic movement in the earth's crust millions of years ago. Not only an interesting phenomenon to be enjoyed by tourists but students of geology travel from all over the world to see and study this unique site.

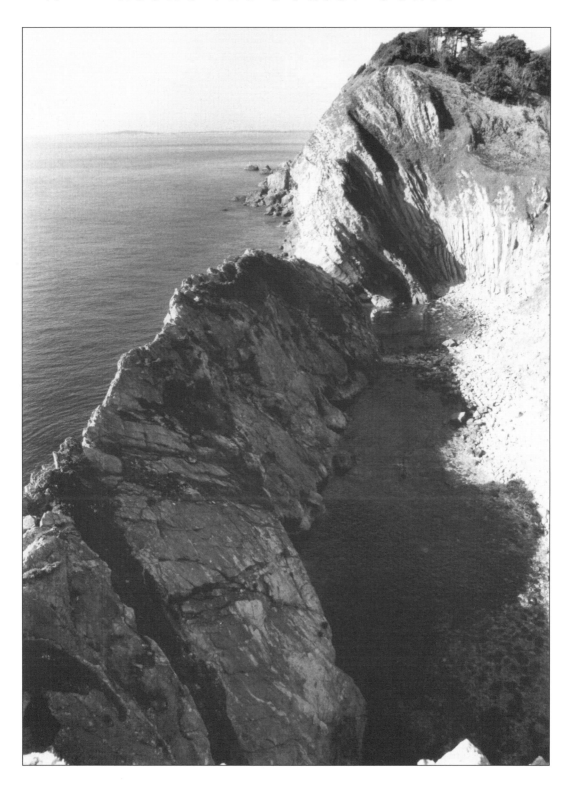

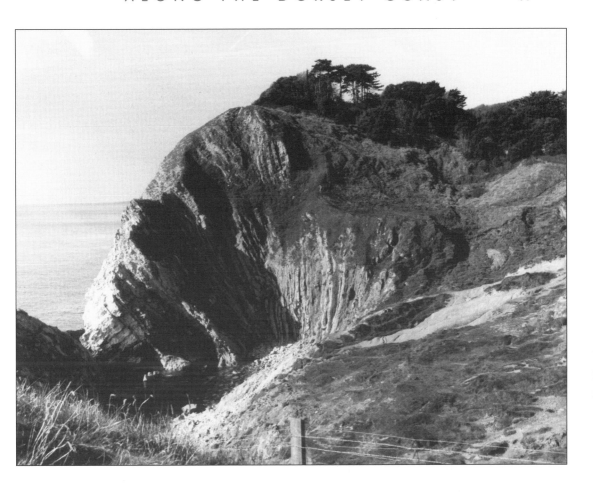

This incredulous 'rock folding' more closely resembles a bomb crater than the result of prehistoric geological creation.

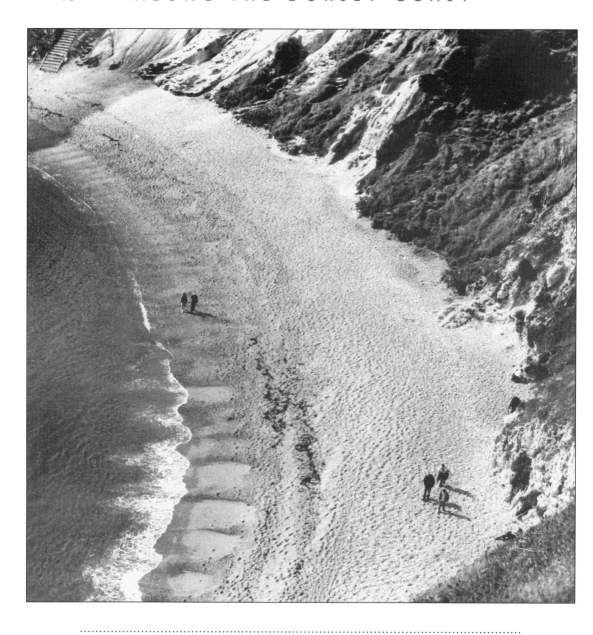

This shot looking down onto St Oswald's Bay is made more interesting by the way that the tide has made patterns in the sand, emphasised by the sinuous white line of the sea at the very edge of the shore.

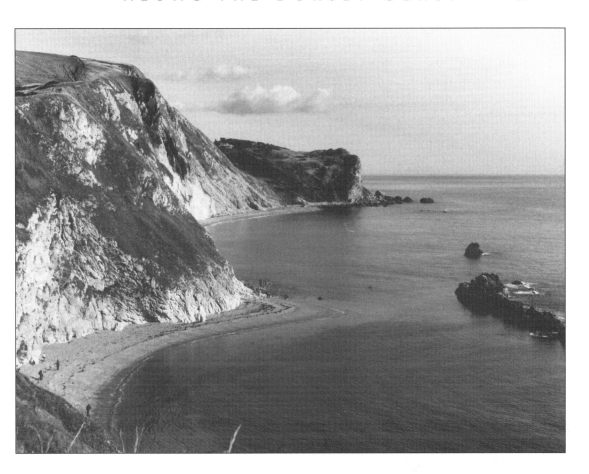

This particular stretch of shore is a remarkable visual lesson in geology. Looking east from Durdle towards Lulworth Cove is the amazing sculptured coastline of Man of War Cove and part of St Oswald's Bay, displaying the powerful effects of the sea and subsequent creation of coves and inlets. At Lulworth Cove there is a heritage centre displaying various exhibitions and information regarding the formation of the landscape of the surrounding area from its early history millions of years ago. It is here, at the centre, that the Lulworth Rangers are based. Their full-time task to maintain the footpath and manage ecology projects can easily be appreciated when visualising the landscape in which they operate.

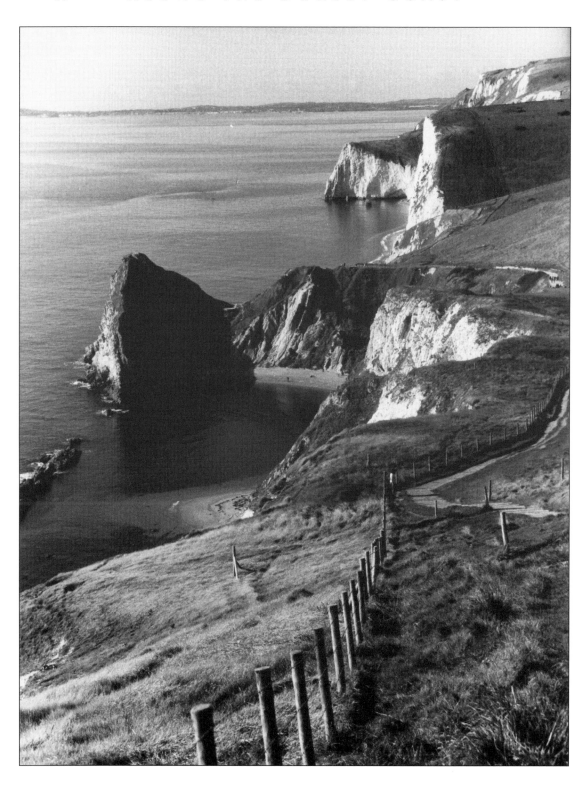

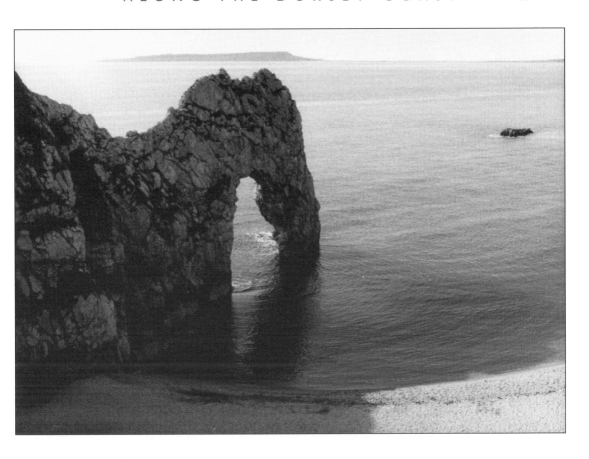

The visual effect of Durdle Door is undeniably dramatic and yet in a strange way it looks as if it could have been man-made. This geological phenomenon, with its massive rock arch, is completely natural and sits at the eastern end of a shingle beach that readily lends itself (on a warm day) to swimming or snorkelling or picnicking or sea-gazing, waiting for the sun to move westward and light up this strange archway.

Opposite: Not only does the area suffer erosion from the sea, but of course there's collateral damage caused by the many thousands of visitors each year. Because of this, management has been forced to take preventative measures, such as steps along certain stretches of the path and some fencing to ensure strict observance of dangerous cliff edges – none of which detract from the stunning beauty of this site that was granted World Heritage Site status in 2001. Interestingly, most of the area is privately owned by the Lulworth Estate, a family estate owned by the Welds.

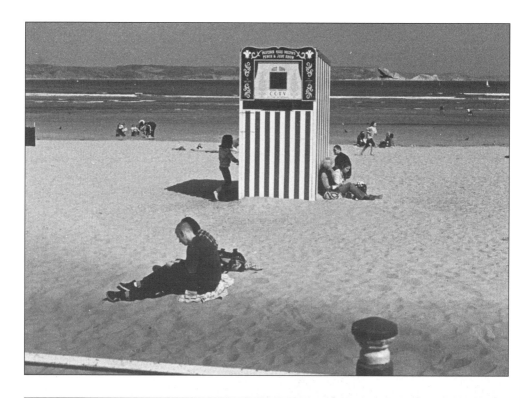

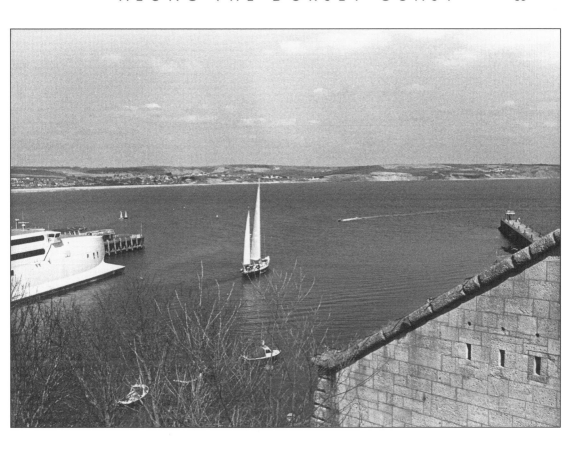

The brilliant white sails, like twin spires, edge out of Weymouth Harbour into the calm of
the channel. However, centuries ago all was not calm; a bitter feud existed between the
north and south side of the harbour until 1571 when Elizabeth I granted a royal charter
uniting them as the Borough of Weymouth and Melcombe Regis.

Opposite: Situated on the north side (Melcombe Regis) of Weymouth Harbour, the long
stretch of sandy beach offers a wide variety of seaside facilities. Unfortunately the Punch &
Judy man had gone to lunch and the swing boats were not attracting too many customers.
However, the sun was dazzlingly bright, the wonderfully clean sand looked golden and the
donkeys looked pleased that there weren't too many takers. Tourism began as early as the
seventeenth century and subsequent frequent visits by George III ensured that this tiny
fishing village was destined to become fashionable. Once described as 'England's Bay of
Naples', Weymouth's beach front has developed astutely, while still maintaining the traditional
family seaside entertainments. The beach has been used as a venue for such events as the
International Beach Kite Festival, sailing championships and volleyball tournaments.
Unlike so many English seaside resorts, Weymouth looks prosperous.

A quiet moment for the café at the end of Weymouth Pier. Hopefully things will have heated up a little by 2012 when Weymouth Bay and Portland Harbour will be hosting the Olympic and Paralympic sailing events. These two sites combined provide some of the best natural sailing waters around the UK. Facilities for the games are already in place, completed within the original budget weeks ahead of the original schedule. Remembering adverse publicity concerning soaring budgets and out of sight completion dates from several previous Olympics, this sounds very much like a first! Once the games are over the National Sailing Academy and local community will hopefully inherit a very modern and up-to-date training facility, providing first-class opportunities for those seeking to improve their sailing skills – but in the meantime, let's look forward to a few medals!

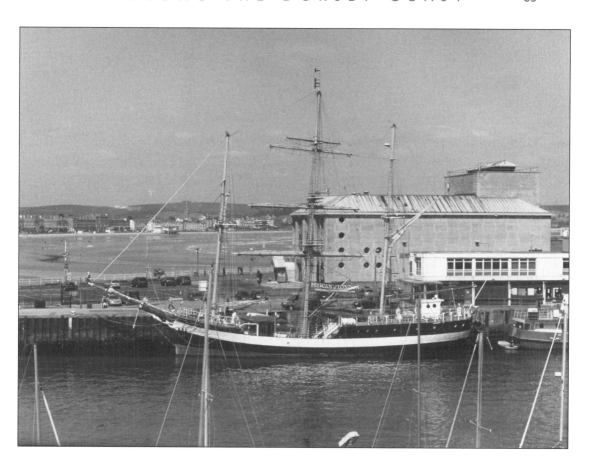

This page and overleaf: Fancy a day's sailing aboard a three-masted tall ship, or crewing on board during the 2010 Tall Ships Race? Both opportunities available with the T.S. *Pelican* whose homebase is Weymouth Harbour. The ship began its career as an Arctic trawler, built in 1948 at Le Havre and aptly christened *Pelican*; she was unique among square riggers as her hull was built on the lines of the late nineteenth-century French clippers with a length to breadth ratio of 5:1. From 1968 to 1995 she operated as a coaster *Kadett*. From 1995 to 2007 she was reconstructed as a sail training ship in survey with the MCA/ BV – since reconstruction only the hull remains of the original *Pelican*. Today's ship has been reconstructed with new decks, bulkheads and pipe work, all complying with the most up-to-date safety standards. For those interested in technical specifications I should add that she is 45m in length, has eleven sails and can travel at a speed in excess of 10 knots under sail. A *Captains Blog* press release from March 2010 says, 'All voyages aboard the *Pelican* are one of challenge and discovery as well as relaxation and good living.' I should think there is something applicable for most tastes within this statement!

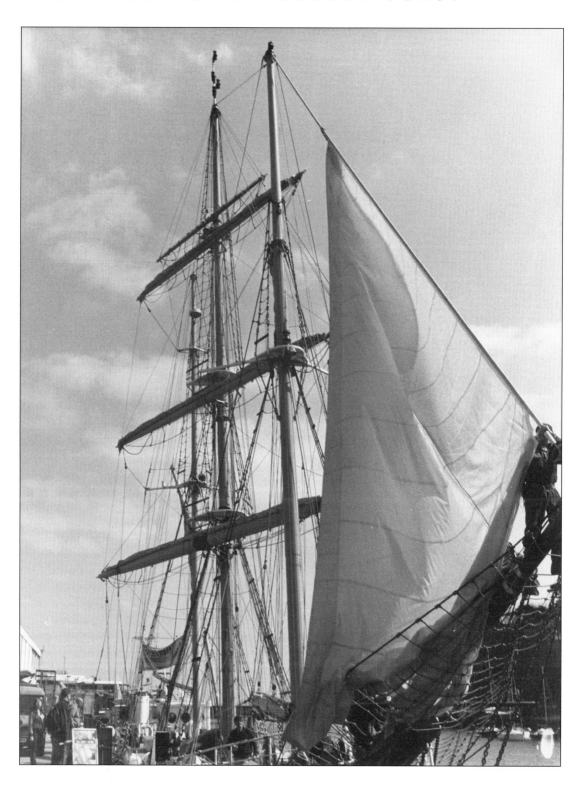

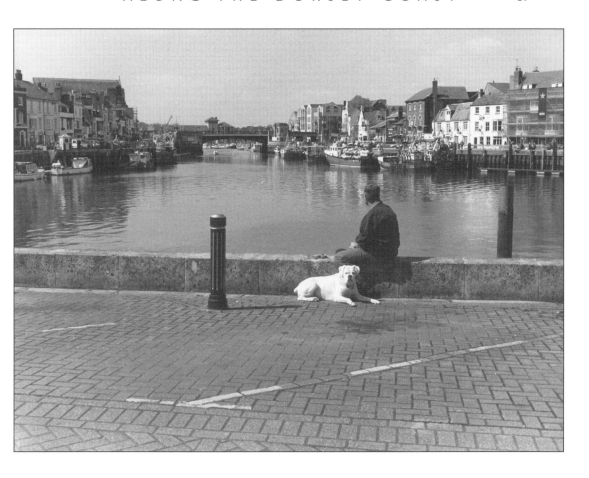

The photograph shows a view of the Town Bridge that was ostensibly a token of unification between the two opposing harbours of Melcombe Regis and Weymouth. Trading rights had fuelled the bitter rivalry between the two sides until Elizabeth I united them under one borough in 1571 – the original bridge had been built in the 1590s. There have apparently been at least six bridges between the original and the drawbridge that we see today (built in 1930), which opens every two hours to allow ships to pass through. I doubt that the gentleman sitting on the quay is contemplating such historical fact, merely enjoying a peaceful scene on a fine day. However, his dog 'Chippy' (I had to ask!) has spotted me with the camera. Is that a look of benign contempt or detached approval?

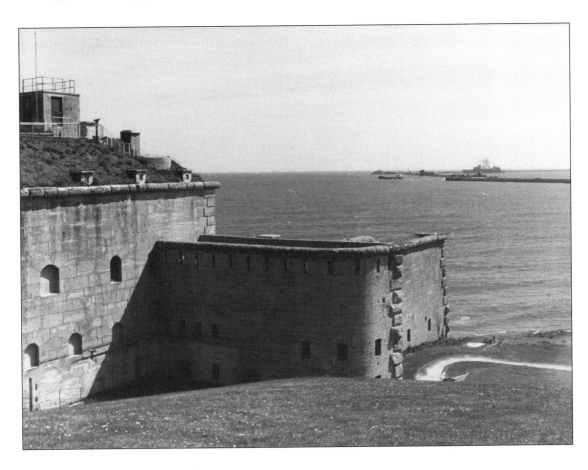

Fort Nothe was built in the 1860s on the advice of a royal commission led by Lord Palmerston.
The government had been concerned about possible offensive overtures by the French and
a review of the country's coastal defences was deemed necessary. The fort was completed
between the mid-1860s and early 1870s having been constructed by a company of Royal
Engineers, apparently assisted by prisoners from a nearby detention centre. It is ideally situated
on the promontory overlooking Weymouth Harbour to the north and east and commands
uninterrupted views across Portland Harbour to the south and west. The main photograph
shows a ship entering the harbour through the North Ship Channel. The harbour is to be
used as a venue for the Olympic sailing in 2010. Avid sailors wishing to watch the events might
volunteer as helpers at the fort (now a museum) during the Olympics.

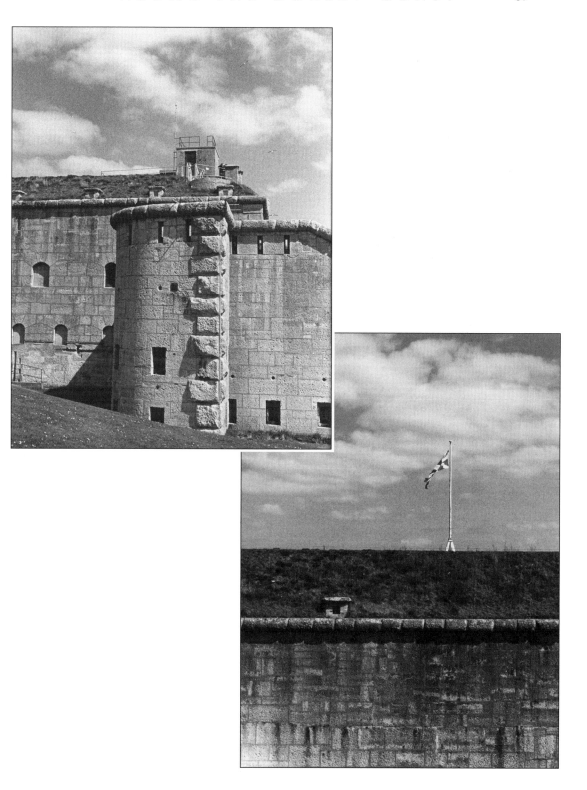

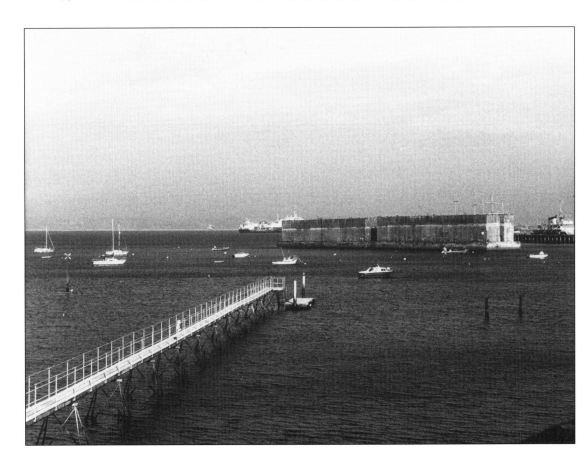

A jetty beneath Portland Castle strikes out into the busy harbour. The harbour, one of the
largest in the world, was started in 1849. Prisoners at the time were used to construct the
breakwaters (they did keep prisoners busy in those days) and, unfortunately, the project
cost the lives of over twenty men. It was completed in 1872. The former naval base has been
in private hands since 1996, the company creating a busy and viable deep water port.

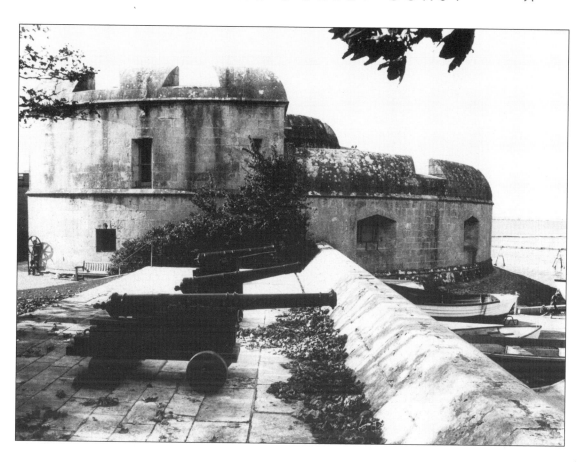

This photograph shows the castle and its heavy cannon waiting patiently for an expected
invasion from the French and Spanish. The castle is yet another one of Henry VIII's protective
defences built in about 1540 to prevent Weymouth from falling into enemy hands. During the
Civil War Cromwell used it to incarcerate his prisoners and in the First World War it was
used as a seaplane station, coming into its own again during the Second World War when it
provided an embarkation site for the D-Day landings. The last fact may well explain the two
large blocks to the right of the previous photograph that look suspiciously like part of what
was a mulberry harbour.

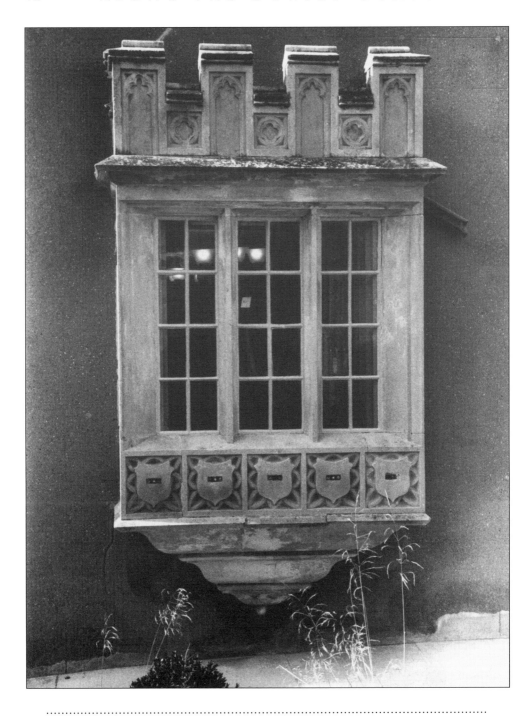

Here is an original Georgian window beautifully worked in Portland stone outside of the tea rooms now attached to the castle.

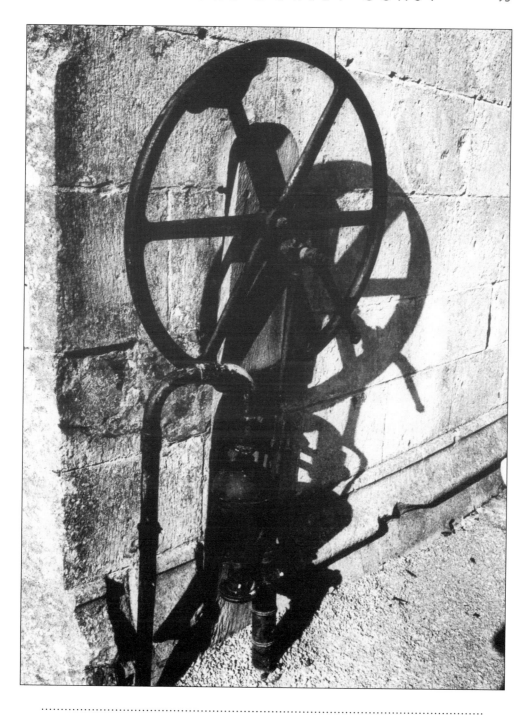

On the outside of the castle wall stands an old hand pump that was used to draw water up from a nearby well. Portland was obviously blessed with plenty of such wells, hence the suffix to many of the local village names, like Fortuneswell, Chiswell and Southwell.

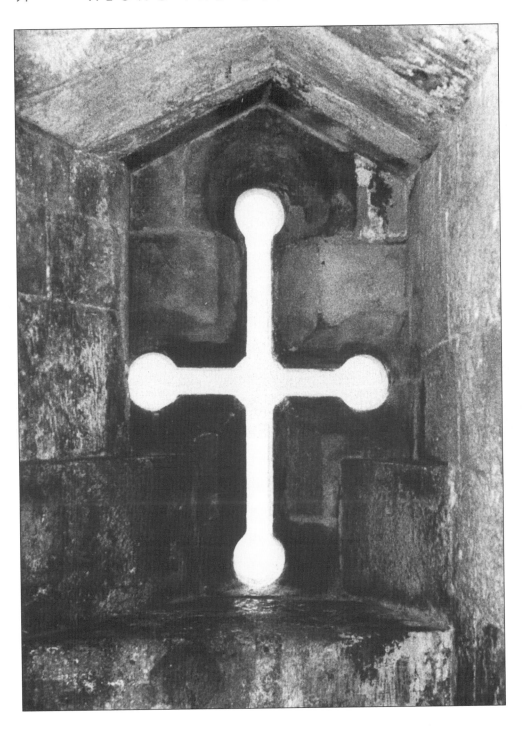

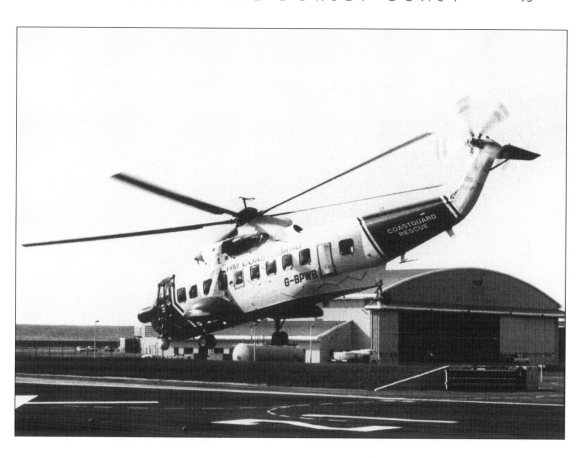

This photograph shows a Coastguard Rescue helicopter taking off from Osprey Quay. The service that has been in existence since 1995 is based on what was originally an air station for the Royal Navy, flying seaplanes from Portland Harbour. The service has subsequently been put out to private contract (what essential service hasn't?) and while there were fears that the service could be axed, the MOD has selected another private contractor to take over the contract from 2012.

Opposite: It is easy to imagine that this impressive cruciform window in the castle walls was the only source of light and connection to the outside world that a prisoner had to hang on to. More realistically, the dungeons below had none!

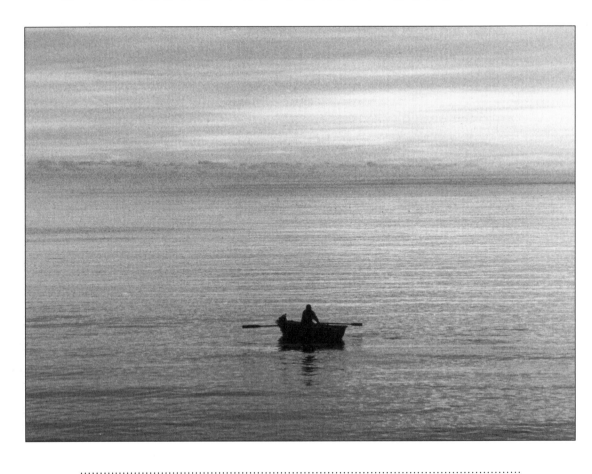

A lone rowing boat heads out into West Bay at sunset – presumably to check some pots before night comes in.

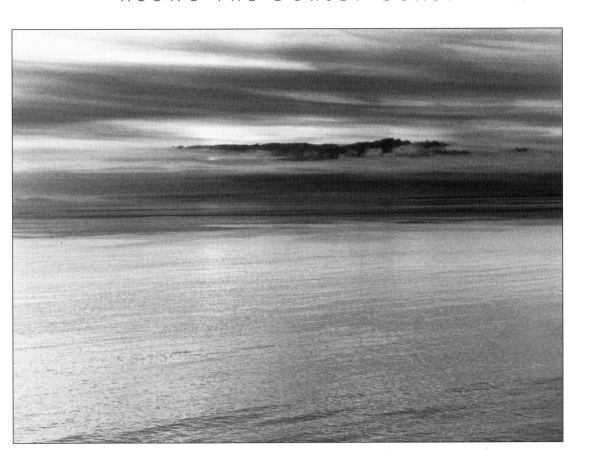

Looking west across the bay from Chesil at sunset.

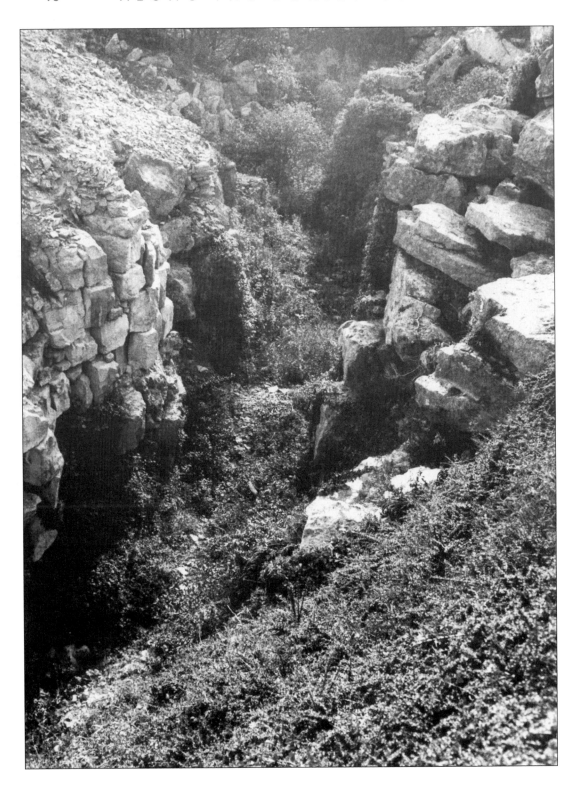

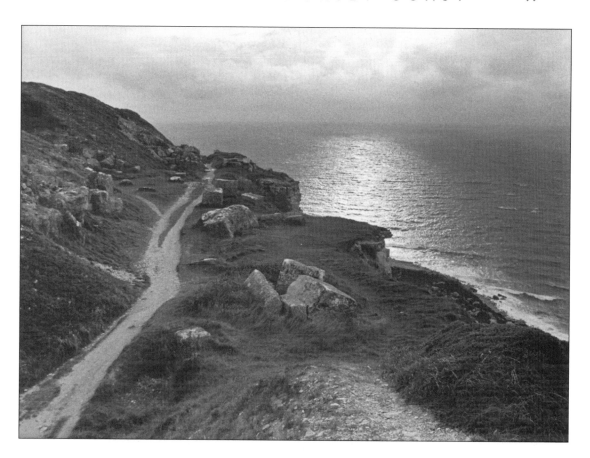

...

Here on the West Cliff, large chunks of stone haphazardly litter the clifftop path, while at the base of the cliff years of quarry spoil have been tipped over the edge onto the shore; not exactly enhancing the natural beauty of the cliff face. Once more nature is doing an admirable job in camouflaging man's misuse – so much so that Tout Quarry is now a Site of Special Scientific Interest (SSSI) supporting rare butterflies and orchids.

Opposite: This photograph clearly shows how nature has gone about repossessing the area now that quarrying has ceased. It looks a perfectly natural ravine!

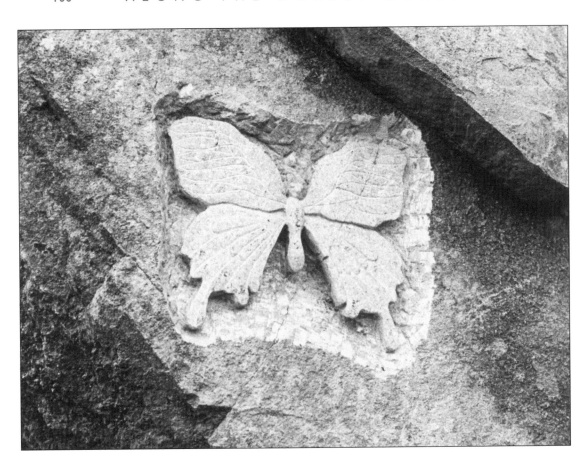

Portland stone is valued and sought after the world over. It is thought that the Romans may well have found use for it but it was certainly well promoted by Sir Christopher Wren, coincidentally one time MP for Weymouth, who used thousands of tons of the stuff to rebuild London after the Great Fire. Apart from being used for such famous edifices as St Paul's Cathedral and the Whitehall Cenotaph, it was shipped to northern Europe to provide headstones for the hundreds of thousands who died on the Western Front during the First World War. Today Tout Quarry, just north of Weston on the Isle of Portland, is home to the Portland Sculpture and Quarry Trust. It is here that in 1983 (the quarry ceased commercially in 1982) sculptural artists began to practice and make use of the abandoned stone, the emphasis being on 'carving stone in its place of origin'. The trust has developed a creative and educational work space within Tout Quarry that has quickly become recognised for sculpture in stone related to the environment. There are many sculptures to be seen varying in size and subject – some are carved directly into the stone or rock face, others on specifically prepared slabs. The trust works closely with six quarrymen and masons and runs courses for the general public over the summer period and caters for colleges and universities during term time.

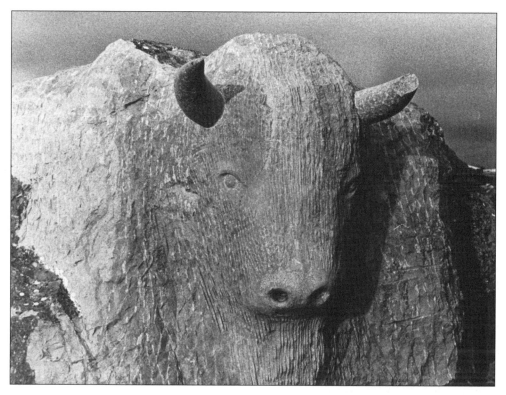

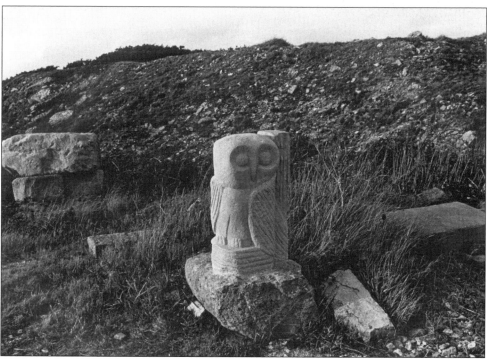

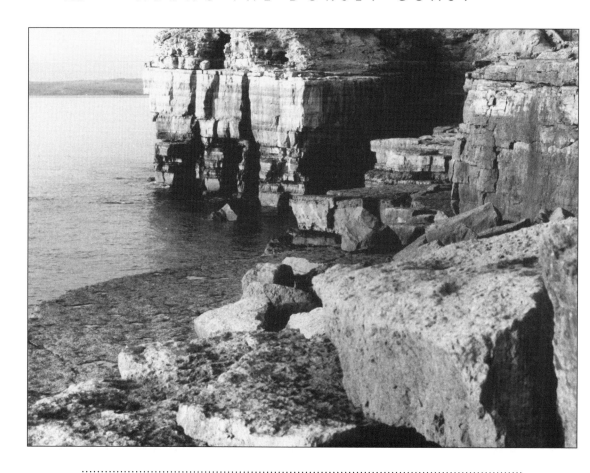

The rock face in the photograph clearly shows the formation of the large stone slabs. The vertical cliff and cave-like entrance is an indication that it was probably caused by cliff-face quarrying in the past. Large pieces of stone would have been lowered directly into barges beneath.

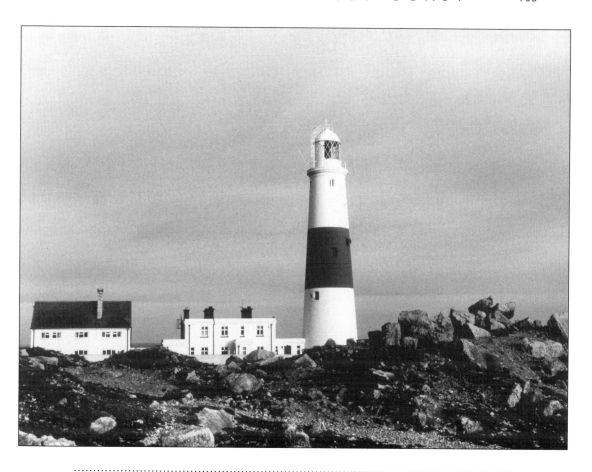

The lighthouse at the southern tip of Portland is 41m tall and, like all lighthouses around the coast of England and Wales, is now fully automatic. When it was still manual and keepers were employed, provision was made for two men and their families to live in the accommodation immediately adjacent to the lighthouse itself. Not too far to commute! Two more cottages were provided, these being detached from the main accommodation. Today the Portland Bill Lighthouse Visitors' Centre is now situated in the redundant keepers' housing. The centre provides a number of interesting displays, covering Portland's geology, environment and heritage, as well as fascinating live video coverage of bird life on the nearby cliffs.

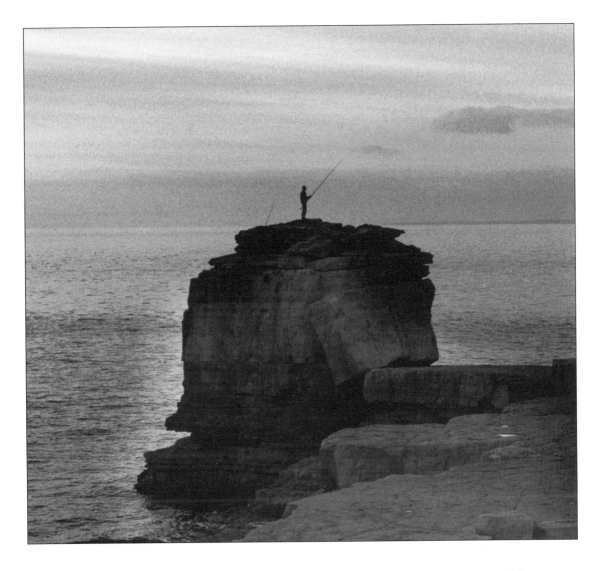

Pulpit Rock at the southern tip of Portland Bill was created artificially; the stack of rock was left after quarrymen cut away a natural arch in the 1870s. It stands distinctive and obdurate, stubbornly defying the wild boiling seas and the wicked tidal races that surround it. This photograph shows a lone fisherman persevering in the fading light. It is just possible to discern a second fishing rod poking up into the sky to his left; that is assuming he is not fishing with two rods!

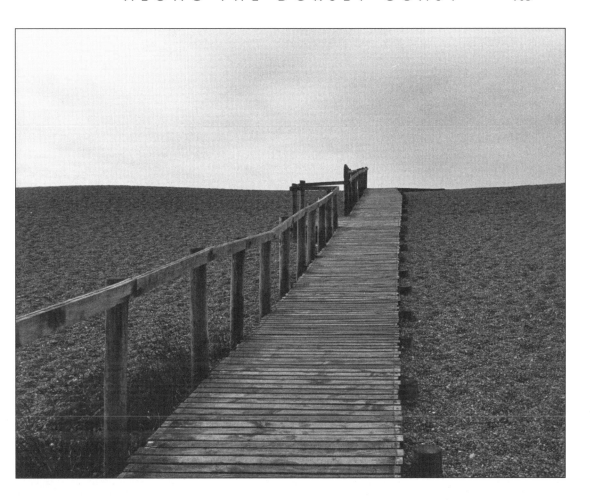

The reasons for the unusual formation of Chesil Beach have been widely discussed and disputed, with the result that there is still no definitive conclusion. One thing, however, is without dispute: the current and strong sea breezes are a positive hazard to any swimmers or sailors who venture from its shore – for swimmers especially there is danger of a strong undertow. This unusual phenomenon is approximately 29km in length and, at its widest, 200 metres in width and an average of 11 metres above main sea level. Although theories of its evolvement are racked with dispute, it is fairly certain that some movement of material from the west is evident – namely pebbles from Budleigh Salterton in Devon ('Budleigh muffins'). Running parallel to the coastline along its length it creates a barrier between the sea and the unique brackish lagoon known as the Fleet.

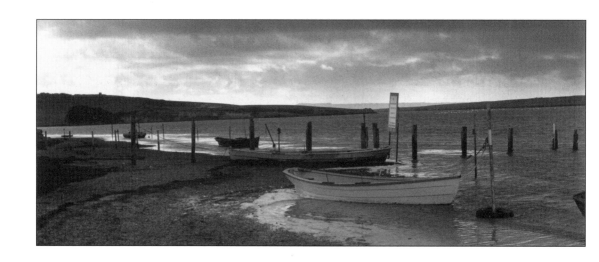

A photograph taken near Abbotsbury Gardens. The gardens benefit from a micro-climate, producing an exotic and almost sub-tropical environment.

Opposite: Both photographs show a serene lagoon and beyond that the solid beach basin of Chesil Beach. Such tranquillity cannot always be guaranteed as, as mentioned before, Chesil Beach is notorious for treacherous currents and unpredictable storms. On 24 November 1824 a powerful storm drove huge waves crashing over the beach arm, flooding the tiny village of Fleet and destroying parts of Weymouth esplanade. The lagoon known as the Fleet is roughly 8½ miles long and has a varying width from around 900 metres at Littlesea and 65 metres at the Narrows. Mostly it is about 2 metres deep with some parts reaching 4.5 metres. Its brackish waters are a mixture of sea waters entering the lagoon at Ferrybridge on Portland Harbour (plus seepage through the shingle bank) and fresh water streams draining into the basin from the surrounding landscape. The lagoon is a Mecca for a vast variety of birds and wildlife, most famously the Mute Swans at the western end near Abbotsbury. The swans are particularly attracted to the large quantities of eel-grass that flourishes on the bottom of the Fleet. These swans have been farmed at this site since the 1300s. The Fleet management of the lagoon (Britain's largest) has banned all boats with the exception of a few that have special licence and fishing is only permitted from the Chesil Beach bank seawards. There is much scientific study and monitoring of this unique habitat using the flat-bottomed boats seen in the photograph. The Fleet and Swanage Trust offer trips around the lagoon in a glass-bottomed boat known as the *Fleet Observer* that sails daily, weather permitting, from a jetty behind the Ferrybridge Inn.

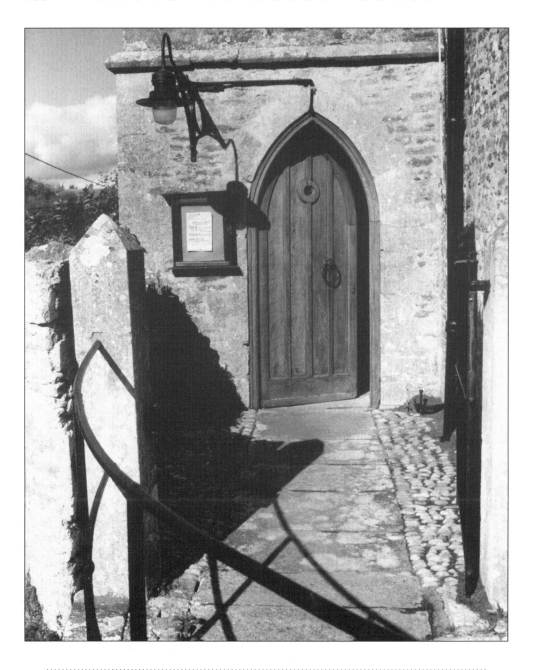

Just above the Fleet sits the picturesque village of Langton Herring, tucked quietly away from the main highway and engulfed by trees and pleasant foliage. The small stone Gothic church is dedicated to St Peter. The church has undergone much restoration and has an eighteenth-century tower. It's still being very much cared for as seen by the small vase of flowers in one of its windows (opposite).

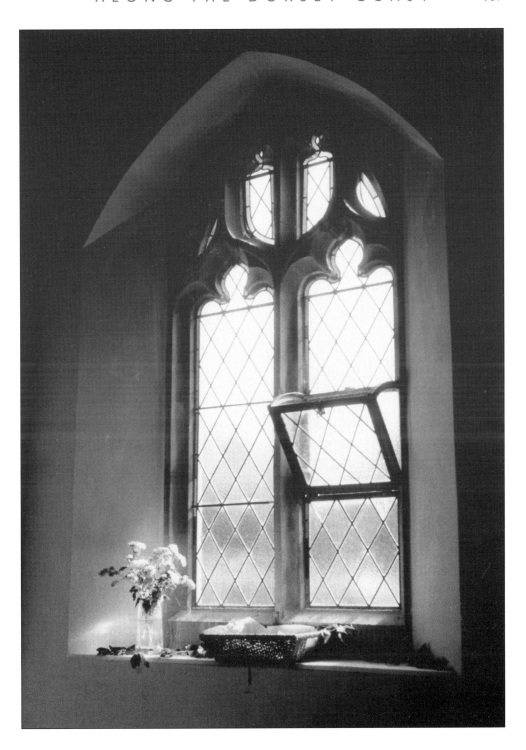

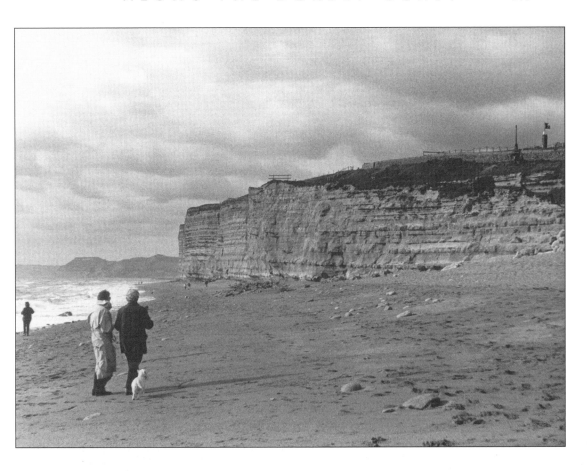

Burton Beach is a long stretch of shingle shoreline just south of Burton Bradstock and is
managed by the National Trust. Beach diving is very popular here, offering a wealth of marine
wildlife for observation that includes pipefish, butterfish, wousse and any number of crabs.
The windswept shore in the photograph could easily make you disbelieve that statement.
The two women with their dog are stoically striding towards Bridport and the yellow
sandstone cliffs in the distance; beyond which lies West Bay.

Opposite: A line of trees behind the Fleet and close to Langton Herring.

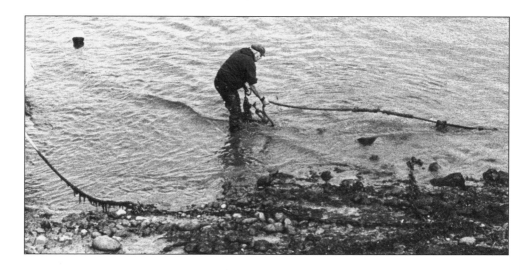

West Bay was once known as Bridport's harbour, Bridport being 1½ miles inland. However, today this charming little harbour has taken on an identity all of its own, no longer feeling the need to be ancillary to the larger town to the north. In a way these two photographs indicate how the traditional and modern have become bedfellows. A fisherman in waders down in the harbour hauls on a boat-line, a task that has probably been performed for centuries. Meanwhile, in the other a lone 'street gymnast' hauls a bench a few feet away from a concrete plinth, takes a run, clearing the lot in a flying forward somersault, before putting the bench back and walking off up the street! These two photographs were taken within ten minutes of each other and only 60 yards apart.

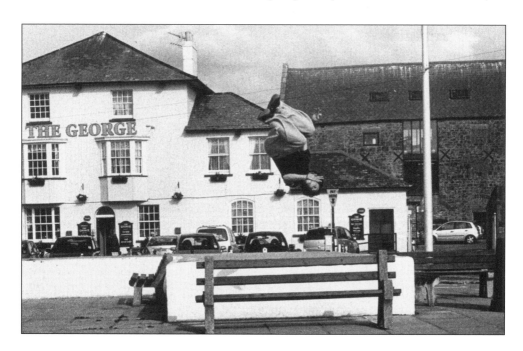

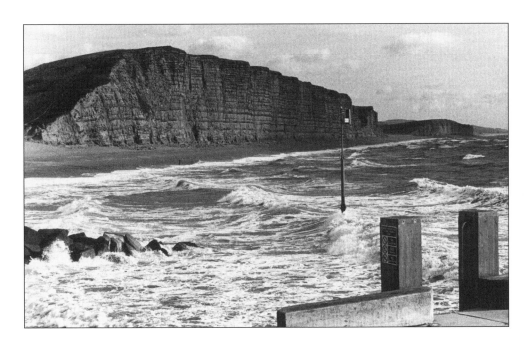

It is easy to see why West Bay is sometimes referred to as the Golden Gateway to the Jurassic coast, with its flamboyant, golden sandstone cliffs to the east, perfectly offset against the white-topped waves. To the west the sandy cliff line can be seen slipping into the mouth of an ever-hungry sea, its white horses continually gnawing for a little more. In the photograph you can just see the granite rocks used as an armour to protect the harbour arm.

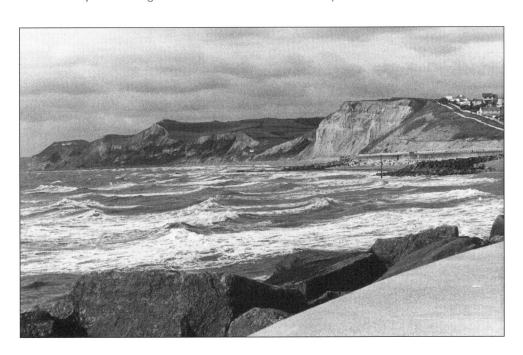

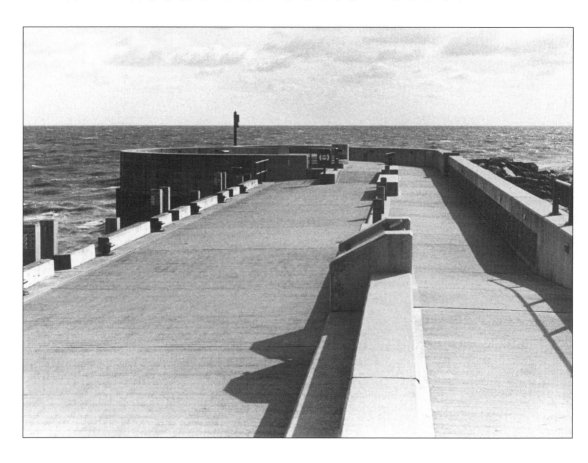

This harbour arm, unusually deserted for a moment, looks oddly naked and exposed. It has a modern look about it, almost everything is made of stone or of concrete with the exception of a few wood pilings. Doubtful if Thomas Hardy would recognise it! He makes reference in some of his works to West Bay using the disguise 'Port Bredy'.

Situated close to the harbour's edge at West Bay, this modern and attractive little chapel was built in the 1930s. The photograph shows the interior of St John's Church with its simple font hit by light from quite modern-looking windows. The window sills displayed several models of sailing ships, supposedly emphasising the church's association with the sea and presumably fishermen working out of the harbour.

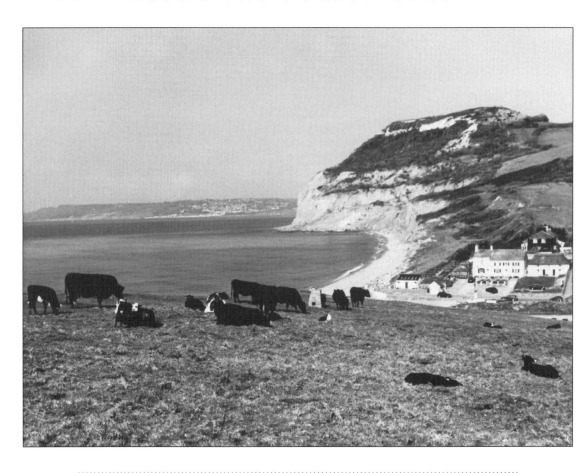

Here we see a view across the tiny hamlet of Seatown (never a town) to the great bulk of Golden Cap – the highest cliff on the South Coast (619ft). Access to this small village beside the beach is down a winding lane from the A35, through the valley, complete with stream that successfully dribbles onto the beach at the end of its journey. Apart from the car park there is only the pub – the Anchor (very busy in summer) – and public toilets on the beach. Being notoriously famous for its reputation as a centre for smuggling, it had in the past its own coastguard station which was disbanded in 1912. The coastguard cottages still remain behind the Anchor Inn.

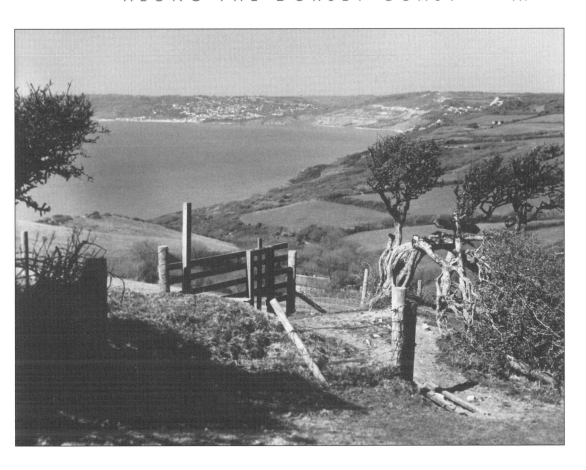

Looking across Lyme Bay from beneath the summit of Golden Cap. This rural scene was taken from just above the ruin of St Gabriel's Chapel looking to the west and away to Lyme Regis and the Devon border.

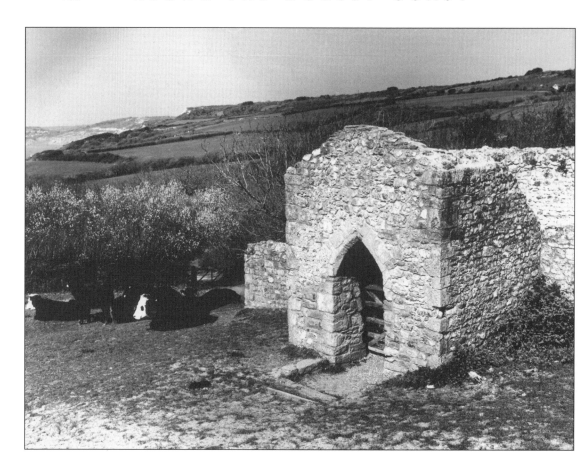

The old chapel at Stanton St Gabriel's has had a chequered career. While Stanton ('Stantone') managed a mention in the Domesday Book in 1086, the chapel's first written reference does not appear until 1240 – mentioned by Robert, first Bishop of Salisbury in an ordinance on Christmas Day of that year. Not exactly the usual Christmas celebration. During the Middle Ages it ceased to be a chapel to serve the local community, who had to trudge further afield to attend Sunday service and during inclement weather were known to complain bitterly – their protestations were ignored completely by Canterbury. In the late 1700s the parishioners were lucky to have one service a month, although some christenings and marriages continued for a while into the nineteenth century. Amazingly an old photograph taken in the late 1800s shows the building intact and topped with a thatched roof. Wouldn't that be a scene with the cattle in the foreground?

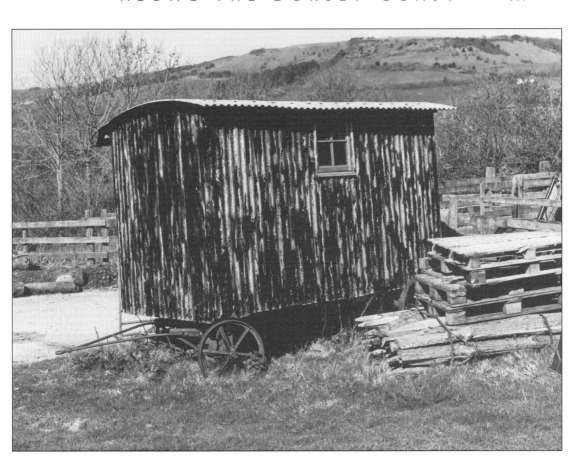

This mobile shepherd's hut was spotted in the yard of a farm just north of Golden Cap. Built with corrugated iron sheets and solid metal wheels it was designed to be towed by a horse to wherever the shepherd required it. There are two of these still in existence on Romney Marsh, as well as just a few of the brick-built kind, known locally as 'Lookers Huts'. A 'looker' would be employed to watch over several flocks at any one time, usually in the employ of absentee landlords. Having the responsibility of so many animals, especially at lambing time, meant being on site twenty-four hours a day; a lonely existence indeed! The hut would have had a fireplace and a chimney built in for warmth and for cooking a meal, but the shepherd required the help of his family to bring him food.

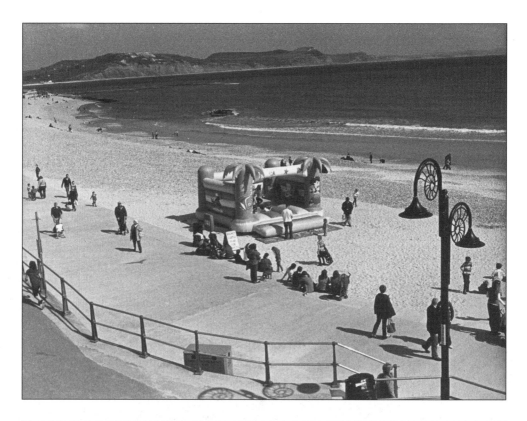

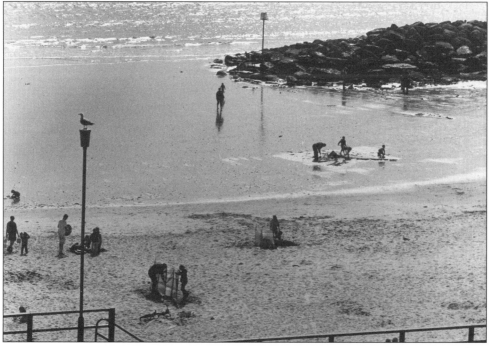

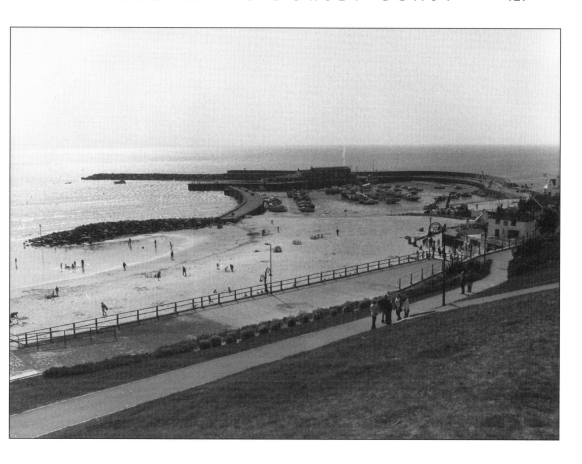

The western end of Lyme Regis showing its sandy bay and harbour and, of course, the famous Cobb. Lyme has relied upon the Cobb for protection against westerly gales since the thirteenth century, when Edward I granted the town a royal charter in 1284 allowing it to add the suffix 'Regis' to its title. Lyme and the Cobb are not only known for wayward women (Fowles's *The French Lieutenant's Woman*) and romantic naval captains (Jane Austen's *Persuasion*), but also for some of the most important fossil finds ever in this country. Much of this material was discovered by the celebrated fossilist, Mary Anning (1799–1847).

Opposite: Looking across Lyme Bay towards Golden Cap. Lyme Regis is blessed with golden sands and gentle shallow water that edges up to the promenade, making it a favourite choice for families on a sunny day. These two photographs were taken early in the season but already groups of people are gathering at the shore, mostly wearing jackets and coats, but a few are bravely beginning to strip! The sea dazzles with sunlight but has a definite cold look about it.

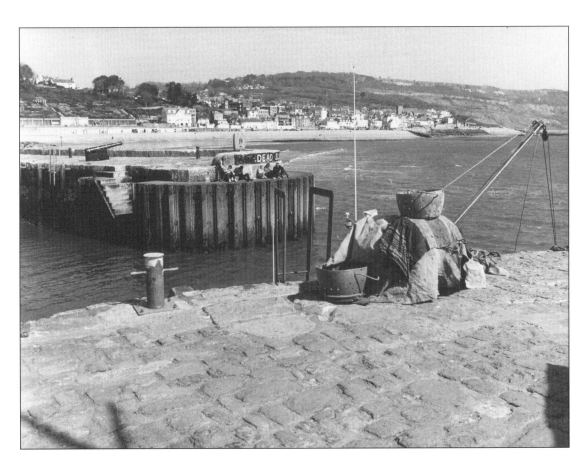

..

The narrow harbour entrance affords a group of youngsters with a prime fishing opportunity, while on the harbour arm in the foreground various fishing paraphernalia is being unloaded from the boat below. It's difficult to imagine that this same pleasant little harbour was at one time a major English port; larger than Liverpool was in the late 1700s.

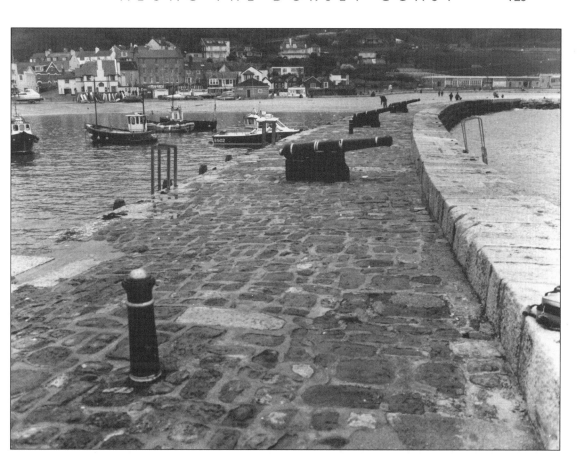

Looking landward along the harbour arm we are reminded by the cannon that the country has perennially been under threat of invasion from one source or another. Lyme prospered, however, largely due to its maritime opportunities that have been wisely exploited. It became a fashionable watering place in the eighteenth century, leaving it a legacy of attractive Georgian architecture imposed upon steep narrow streets and alleyways. Today it continues the tradition of encouraging and serving visitors.

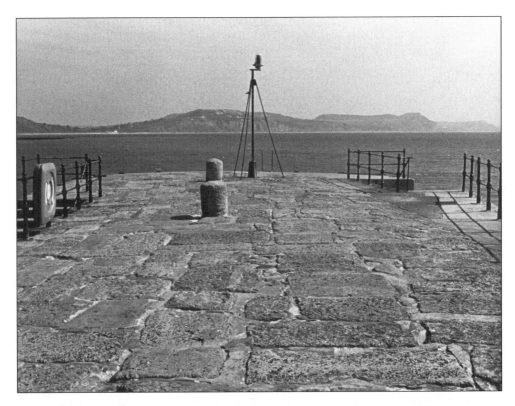

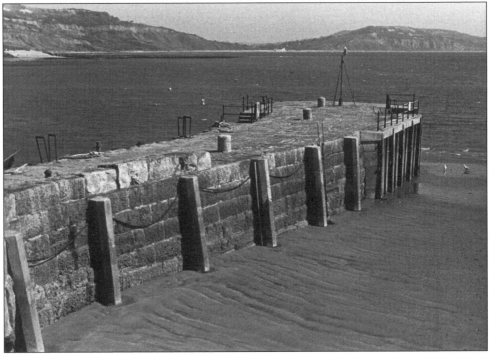

Steps along the Cobb – pure geometry!

Opposite: These two photographs show part of the Cobb with Lyme Bay stretching away in the distance. Over the years the Cobb has acted not only as a harbour but as a breakwater as well – these two aspects were necessary ingredients to allow the town to develop a shipbuilding industry as well as operating as a major port. Much of the port's trade was with the continent exchanging wine for wool – not a bad swap! With the increase in the size of shipping, trade declined and Lyme took on semi-retirement, mellowing into an age of fashionable seaside resort and retirement nests. It acquired the soubriquet 'The Pearl of Dorset'. Earlier versions of the Cobb were built of wood piles behind which were stacked great heaps of stone, or boulders, known as 'cow stones'. Barrels were used to float these enormous rocks into position. This makeshift barrier suffered continuous damage from storms prevailing from the west. In the early 1800s it was finally rebuilt using Portland stone – the great, rugged slabs can clearly be seen in the photographs.

This imposing stone superstructure at the eastern end of the promenade actually disguises a
modern sewage works – the scheme has rightfully attracted a number of awards. The project,
completed in the mid-1990s, has effectively extended the esplanade walls, encouraging
strollers to look beyond the edge of the town along the bay towards Charmouth. The small
but intricately neat stonework compliments the broad slabs of stone on the Cobb at the
promenade's western end. The area has the practical and romantic title of 'Gun Cliff Walk'.

A view down to the sea from Gun Cliff Walk.

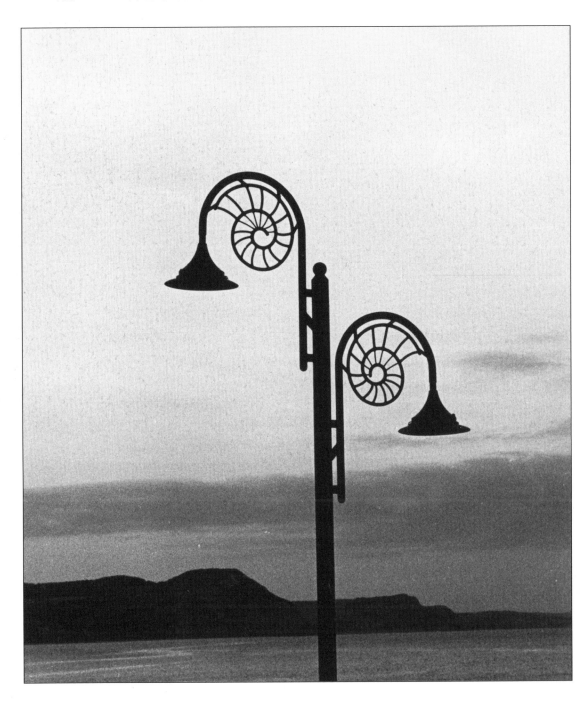

As dusk approaches, here is a last view looking back across Lyme Bay towards Golden Cap.
Notice the distinctive motif on the street light in the foreground – a pair of ammonites.
Wonderfully apt!